IMAGES
of America

MEMPHIS
MOVIE THEATRES

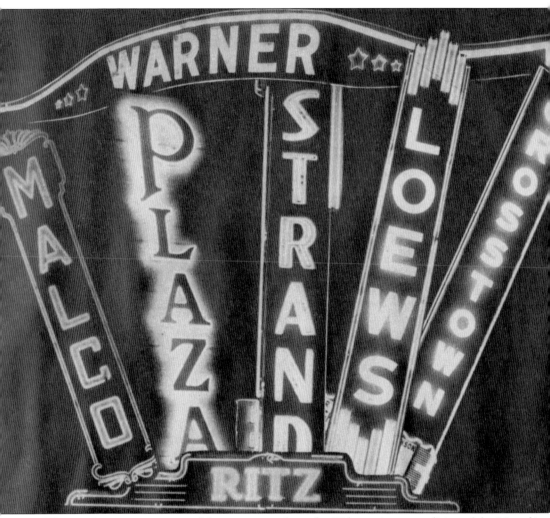

This graphic representation of theatre signs is from the 75th-anniversary edition of the *Memphis Press-Scimitar* (Wednesday, October 12, 1955) and is used to illustrate the entertainment column The Front Row by critic Edwin Howard. The actual verticals, particularly the Malco and Crosstown Theatres, dwarfed the Strand Theatre sign, which was part of its marquee. (Courtesy Memphis Public Library and Information Center, Memphis and Shelby County Room.)

IMAGES
of America

MEMPHIS
MOVIE THEATRES

Vincent Astor

ARCADIA
PUBLISHING

Published by Arcadia Publishing
Charleston, South Carolina

Printed in the United States of America

Library of Congress Control Number: 2013933264

For all general information, please contact Arcadia Publishing:
Telephone 843-853-2070
Fax 843-853-0044
E-mail sales@arcadiapublishing.com
For customer service and orders:
Toll-Free 1-888-313-2665

Visit us on the Internet at www.arcadiapublishing.com

To Angela Garavelli Astor for her Majestic stories and Vincent Finis Astor who, looking in the Malco orchestra pit, said, "That's a great big pipe organ." The rest, as we say, is history.

CONTENTS

Acknowledgments 6

Introduction 7

1. From Storefronts to Palaces 9

2. Main and Beale 35

3. "Colored" Balconies, "Colored" Theatres 51

4. Coming to Your Neighborhood Theatre 65

5. I Remember That! 81

6. Divide and Conquer 93

7. Selected Shorts and Survivors, 2013 105

ACKNOWLEDGMENTS

I hope some of the many scattered stories and images that tell the tale of Memphis Movie Theatres can now be found together in this book. Thanks now go to those who have been most generous with their time and resources. I cannot list each person, but everyone will find the correct name with the correct photograph.

June West, Carrie Stetler, and Matt Ducklo of Memphis Heritage have been unfailing in their support and encouragement and my access to the Don Newman collection of photographs was without restriction. It began because I needed a place to store a five-foot plaster urn—just about all that's left of the Warner/Pantages theatre (credit—Memphis Heritage, Newman Collection).

I don't think I could ever be as patient and helpful as the staff of the History Department and the Memphis and Shelby County Room of the Memphis Public Library and Information Center have been to me. I am proud to be a library volunteer (credit—MPLIC).

The staff of Special Collections at the Ned McWherter Library of the University of Memphis has my heartfelt gratitude (credit—University of Memphis Library). The Shelby County Archives found buried treasure as did the Police Department and Fire Department Archives. John Sale at the *Commercial Appeal* and Robert Dye at Graceland contributed rare images. Malco Theatres, Inc. and the Orpheum Theatre contributed past and present images. Contributors to Cinema Treasures and Memphis in Pictures gave me leads, links, and wonderful trivia.

I was amazed and delighted to find other images of Memphis theatres in the American Theatre Historical Society of America's American Theatre Architecture Archive, the Wisconsin Historical Society, and the San Francisco Public Library. Thanks also go to the Greater Memphis Chamber of Commerce for its assistance, to Dr. Earnestine L. Jenkins for advice, and to Jane Cullins Sanderson, my first contact.

The headliner is always second to the end on a vaudeville bill. Thanks go to Liz Gurley, my acquisitions editor at Arcadia, for her constant optimism, excitement, advice, and savvy that helped me see this through.

Thanks go to Bob Ferguson, Michael Cianciolo, and Carolyn Hays for multiple photographs and for research by Maureen Thoni White, Dave French, and Gene Gill.

Theatre decor has come full circle as theatres transition from plain to fancy and from film to digital projection. It is not known how many smaller theatres will close due to this development—as radical and far-reaching as the advent of sound. Time will tell.

INTRODUCTION

Memphis, Tennessee, was founded at a crossroads. The river was comparatively narrow, the bluffs were high, and a river port was feasible. It was possible to channel all sorts of goods down the river and across the river at Memphis. Railroads eventually connected the river with the East Coast then later crossed the river at Memphis to reach the West Coast. The railroad that connects the Gulf of Mexico to Lake Michigan passes through Memphis. All of these routes have brought thousands of people through the city; many found it amenable enough to stay. After all, the name Memphis is said to mean "place of good abode."

Memphis has always been a theatrical town. A troupe of comedians performed in a private home as early as 1829, just 10 years after Memphis's founding, and a new showboat troupe made Memphis its first stop in 1836. People from large areas in three states, referred to as the Mid-South, were drawn to Memphis because it was closer and, many times, more cosmopolitan than their state capital. It is the largest city between New Orleans and St. Louis, and a major river crossing.

Theatre listings can be found in the earliest city directories and newspapers list theatrical performances throughout the entire history of Memphis. A theatre is visible in a famous drawing of Union soldiers raising the flag over a conquered Memphis. Some buildings were built to be theatres; many were converted from other uses. The first showing of the Cinematograph was held in 1896 at a theatre on Main Street near Linden Avenue, which had been converted from a carriage/streetcar barn.

Movies appeared on Main Street as early as 1905 and the tiny Nickel-Odeons spread like kudzu vines all over town. As early as 1907, there was a "white" nickelodeon on south Main Street and one on Beale Street in the heart of the "colored" community (*colored* being the preferred adjective at that time). These were only a few city blocks from one another. Movie houses came, went, proliferated, and disappeared in both communities; over 50 names of movie houses can be found in city directory listings before the first grand "movie palace" opened in 1920. Memphis had its Gem, Idle Hour, Bijou, Beauty, Electric, Rex, Rialto, and multiple Majestics. Storefronts grew into buildings; buildings grew into movie palaces. Movies were shown in neighborhood theatres as well as downtown; the earliest of these—the Lamar, Linden Circle, Madison, Peabody, Rosemary, Newman, and Suzore—were built in the late 1920s and had long lives. Several "airdomes" were not even completely enclosed.

From the very early days, several local families—some of them Italian immigrants with names like Barrasso, Cianciolo, Zerilla, Maceri, and Pacini—began to see the potential in this new novelty. Members of the Cullins and Evans families began by working backstage and in the orchestra and later built and operated theatres. Beginning in the 1930s, the Lightman family entered the local movie business and still operates most of the movie theatres in the Memphis area. Kemmons Wilson was a movie entrepreneur before he built the first Holiday Inn. Memphis was a busy center for film distribution as well as exhibition. Memphis had its own Film Row, with offices for the major studios and distributors.

The coming of sound films caused costly but necessary investments, and movies were still plentiful during the Great Depression. By this time, the storefront theatres had all reverted to retail. Movie theatres flourished in both communities, though some were better appointed than others. Beale Street had four busy theatres with facilities for live entertainment. The Palace Theatre on Beale Street was better known for its live acts, which included both local performers and those with national reputations.

In 1940, Malco Theatres (M.A. Lightman Company) purchased the Orpheum Theatre and renamed it the Malco. The Malco Theatre and Malco, Inc., figured prominently through the decades that followed.

During World War II, more people passed through Memphis than in any other time previously. They sought entertainment and went to the movies, sometimes during extended hours. The theatres also participated in bond drives and helped to keep morale high, as the nickelodeons had for World War I. The prosperity that followed the war caused even more neighborhood theatres to be built. One was named for W.C. Handy and served the Orange Mound community with both movies and live entertainment. Elvis Presley attended some of the "whites only" shows and participated with Melrose High School students in talent shows at the Handy.

The drive-ins and larger neighborhood theatres spread movie-going to the suburbs and beyond. Memphis's first large shopping center, Poplar Plaza, contained one of the city's larger movie theatres. In outlying neighborhoods and in the county were eight drive-ins. The nearby towns of Millington, Collierville, and West Memphis had movie theatres.

In 1964, the Paramount Theatre opened. It was the last of the large, single-screen movie theatres to be constructed. Times and habits were changing. The era of the "colored" theatre and the "colored" balcony was about to end. The downtown theatres closed one by one, and neighborhood theatres showed adult films or were turned to other uses. The Princess, Strand, and the still-palatial Loew's State and Warner fell to urban renewal. The first multiplex, Malco's Quartet Cinema, opened in 1971. The use of the word *cinema* was also new; it ended the practice of at least a small stage platform in front of the screen. Malco moved out of the Orpheum building into another quartet, the Ridgeway Four. These first two multiplexes were followed by others and by the twinning of the Plaza and Paramount.

Theatre ownership and operation passed from local hands to large chains; Malco Theatres became the exception. Multiple screens (usually four) came and went and left no trace. Shopping centers wanted to offer movies along with retail, but sign restrictions made elaborate entrances and marquees disappear. When Malco's Majestic Theatre opened in 1997 in its own freestanding building, elaborate outdoor displays and large lobbies returned. Rather than gilt and crystal, neon graphics and huge promotional displays decorate the new lobbies, and instead of double features, there are many choices.

Cinemas of the mid-21st century have changed into showplaces again, with themes, fine architecture, and contemporary amenities. As their predecessors, the movie palaces, they still rely on good presentation, good location, comfort, and the ever-changing magic of the movies. Cue house lights down, curtain up, overture, main title; sit back and enjoy.

One

From Storefronts

to Palaces

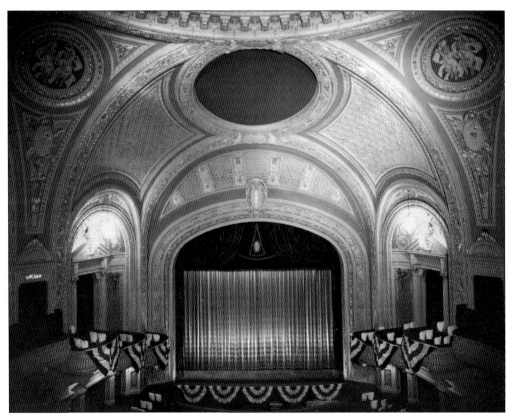

There once was a place of Grandeur and Comfort called the Movie Palace . . . Here in this pretty world, Vaudeville took its last bow . . . Here was the last ever to be seen of Ushers in Uniform and their Concessionaire Counterparts, of Cartoon, Short and of Newsreel. Look for it only in books, for it is no more than a dream remembered. An Institution gone with the wind . . . Warner/ Pantages Theatre, 1943. (Courtesy of MPLIC.)

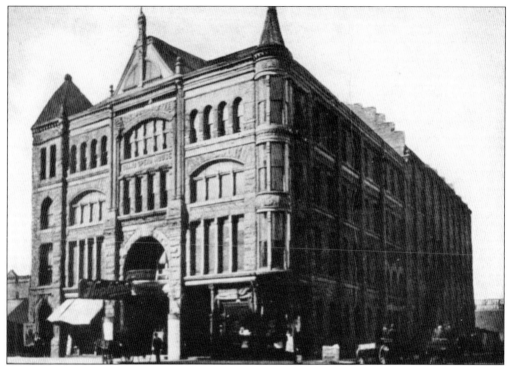

The Grand Opera House was built in 1890 on the corner of Main and Beale Streets and was the finest theatre in the area. Opening nights were gala events and the appointments were sumptuous, including both gas and electric lights. It spent some years under the management of John D. Hopkins, and became the Orpheum in 1907, with vaudeville and early movies. (Courtesy of Memphis Public Library [MPLIC].)

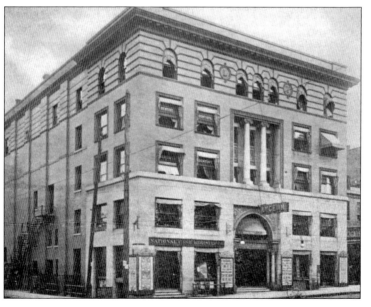

This is the second Lyceum Theatre, built in 1894 to replace a predecessor built in 1890 and destroyed by fire in 1893. It was entirely lit by electricity, and its multitude of ceiling fans made the Memphis heat bearable. There was fierce competition between the Lyceum and the Grand Opera House for operas, dramas, stock companies, and other stage fare. Movies and vaudeville would appear later. (Courtesy of MPLIC.)

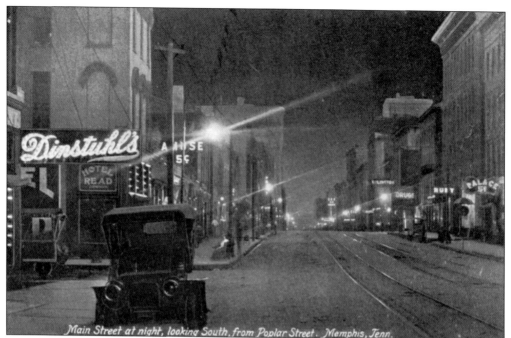

Main Street at night, looking South, from Poplar Street. Memphis, Tenn.

This 1907 postcard shows three theatres on north Main Street at Washington Avenue. Just out of frame are Charles Dinstuhl's candy store and his Theatorium movie theatre. The other theatres are the Amuse on the left and the Ruby and Palace on the right. An Amuse U theatre stood at another location; the names of these storefronts were frequently changed as management changed. (Courtesy of the Dinstuhl family.)

Charles Dinstuhl Sr. founded the successful candy company in Memphis that still bears his name and is operated by his descendants. He opened the Theatorium in 1905, and it is considered the first movie theatre in Memphis. He sold it to Frank Montgomery in 1908. It became the first in a long line of Montgomery's Majestics. (Courtesy of the Dinstuhl family.)

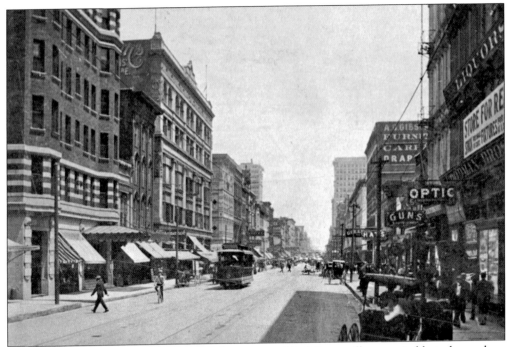

This view of south Main Street in 1907 shows several buildings still recognizable today such as the Hotel Gayoso building and the Goldsmith's building. The tiny Optic (5¢ Moving Pictures) was the first theatre to open at this address. Several theatres that came and went in this block would illustrate the three most important factors in opening a movie theatre—location, location, and location. (Courtesy of MPLIC, Pink Palace Collection.)

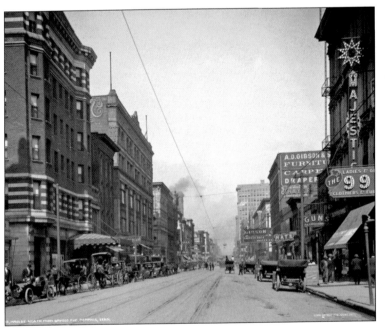

The slender "Majestic #2" sign has replaced the Optic sign in this photograph from 1909. The signs reading "Guns" and "Hats" have not changed, but the theatre would become the Empire No. 2 when a new building further north, just past the Majestic sign, became the New Majestic No. 2. (Courtesy of the Library of Congress, Detroit Publishing Company Collection.)

This advertisement appeared in *Memphis Greets You* in 1916. It represents five of the Majestic Amusement Company's theatres: at center is the New Majestic No. 1; upper left is the New Majestic No. 2; upper right is the most elaborate of the storefronts, the Majestic No. 1; the lower two storefront theatres both were named Majestic, then Empire (No. 2 is on the right). (Courtesy of the Greater Memphis Chamber of Commerce.)

This view from 1920 shows a crowd gathering to watch a parade. The Bijou Theatre, with its three arches, is in approximately the same location as the Optic and Majestic, but would soon be eclipsed by the newly opened Loew's State. The marquee reads "Twenty Movie Stars, *The Price of Redemption*," which played the State not long after its October opening. (Courtesy of MPLIC, Pink Palace Collection.)

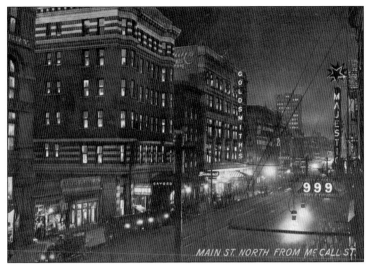

Before there were numerous streetlights, businesses open at night hung two very large globe lights outside their entrances. They appear on the Hotel Gayoso canopy as well as on the Majestic. Movie theatres retained them for a long while until the advent of illuminated marquees, sometimes using both. (From *Night in Memphis*, 1911, courtesy of MPLIC.)

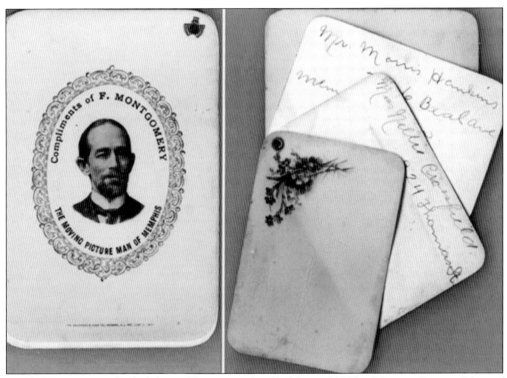

Frank Montgomery hailed from Chicago and called himself "The Moving Picture Man of Memphis." He opened a number of storefront theatres and constructed the buildings housing two of his Majestic theatres. His hallmark was better lighting, ventilation, and overall-improved presentation. He also owned theatres in other cities and was considered a master of advertising, as shown in this calling or note card. (Courtesy of Birch from Memphis.)

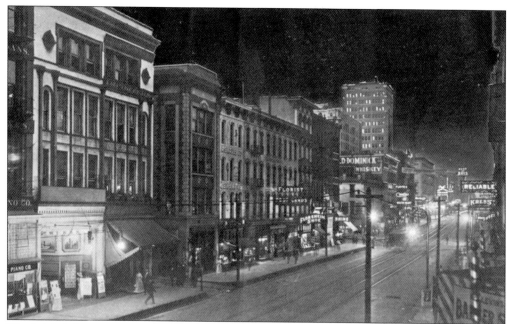

The brightly lit opening on the lower left is the Royal Theatre on south Main Street. The ornate building where it was located has been recently restored. A Royal Theatre was listed in two different locations downtown. Another Royal Theatre opened as the Shamrock in 1915, then housed the Rex in 1926, and was renamed the Royal after its conversion to sound. (From *Night in Memphis*, 1911, courtesy of MPLIC.)

Crowds are gathering for the 1924 Confederate Veterans Reunion Parade. The Empire Theatre No. 1 is visible on the left, behind the second streetlight. There were two theatres in this block; the Colonial (also known as the Beauty and the Richard) is just out of frame. The Columbian Mutual Tower, the tall building in the center of the photograph, is under construction. (Courtesy of University of Memphis Library, Special Collections.)

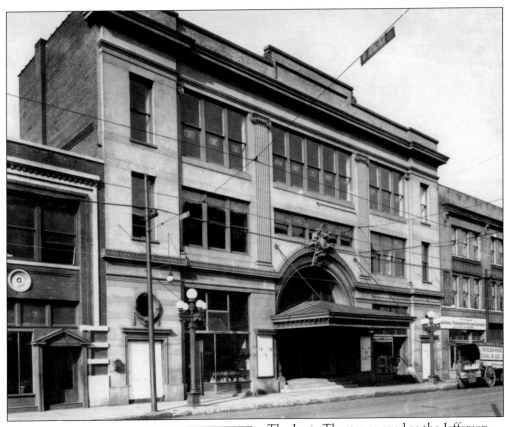

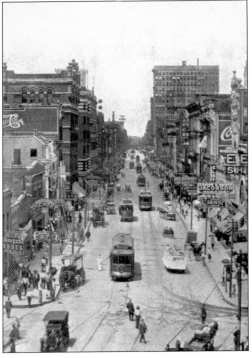

The Lyric Theatre opened as the Jefferson Theatre in 1908. It was named for actor Joseph Jefferson, whose most famous character was Rip Van Winkle and who had a childhood connection with Memphis. It became the Lyric Theatre in 1911. Several significant events took place there, including the first radio broadcast of opera in Memphis and a controversial run of *King of Kings* during its film and vaudeville years. The building burned in 1945. (Courtesy of MPLIC.)

This view from Main and Beale Streets shows four theatres in 1911. The crescent-shaped "Theatre" sign on the left is on the early Odeon theatre operating as the Columbia (notice the Orpheum café). Behind that is the Princess, under construction. The arch under the EEE sign housed the Alamo Theatre, and a dark line close to center is the star-crowned Majestic No. 2 sign. (Courtesy of the Greater Memphis Chamber of Commerce.)

The Princess Theatre was built in 1911, and was the most ornate of the early theatres. It seated over 600 and had one of only two stud-lighted facades on Main Street. The round sign on top of the lone streetlight most likely says "Princess Theater." It is the only theatre building that spelled, clearly, in terra-cotta, "Theater" instead of "Theatre." (Courtesy of Richard Brashear.)

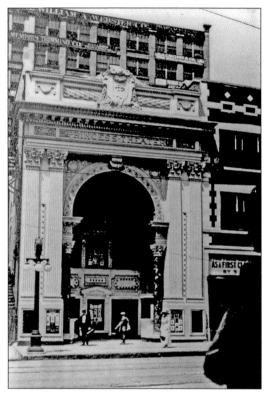

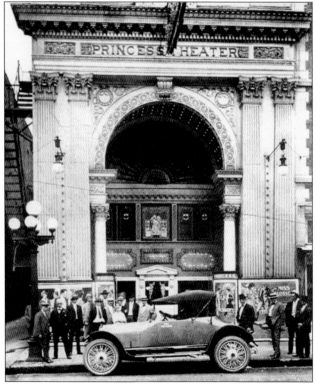

A more detailed photograph shows the deep, arched entry and its lighting. It appears in *Memphis Greets You* in 1916, and has new streetlights, the ubiquitous large globe lights, new advertising frames, and a high-class sporty roadster in front. It is not known which was being emphasized, the theatre or the roadster. (Courtesy of the Greater Memphis Chamber of Commerce.)

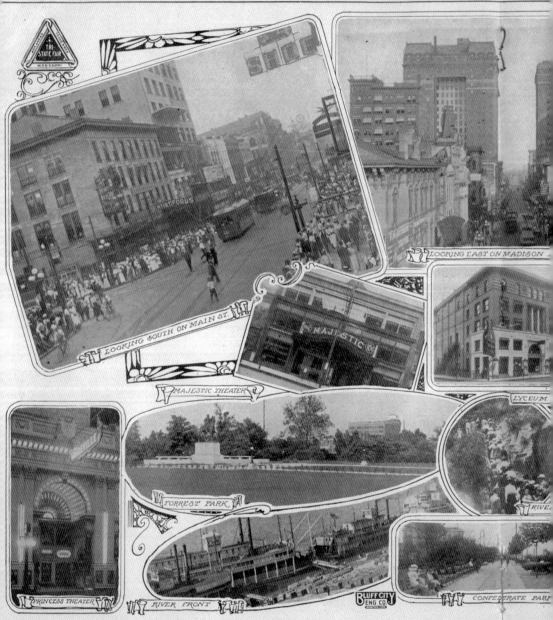

TRI-STATE FAIR MISSISSIPPI

LOOKING SOUTH ON MAIN ST.

LOOKING EAST ON MADISON

MAJESTIC THEATER

LYCEUM

FORREST PARK

RIVER

PRINCESS THEATER

RIVER FRONT

BLUFF CITY ENG CO

CONFEDERATE PARK

Busy Shopping District, Fine Theatres, and Magnificent Pa

17

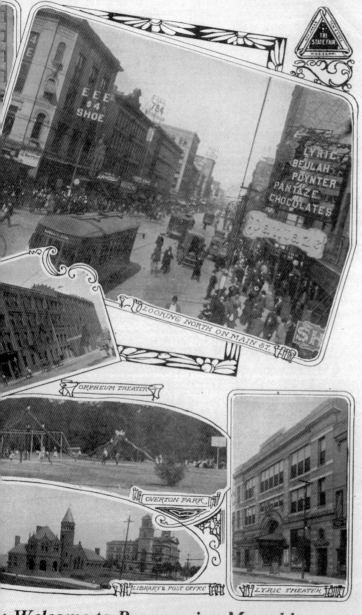

LOOKING NORTH ON MAIN ST.

ORPHEUM THEATER

OVERTON PARK

LIBRARY & POST OFFICE

LYRIC THEATER

Welcome to Progressive Memphis

The Tri-State Fair drew from the area called the Mid-South—the parts of Tennessee, Arkansas, and Mississippi that are closer to Memphis than to the locations of their individual state fairs. The Memphis Commission Government's monthly promotional magazine from September 1913, during the fair, showcases the city's other attractions and amenities. The Princess Theatre is seen lit at night when still pristine. The Majestic No. 2 is beside the Lyceum Theatre, which was not yet showing films. The Beale Street side entrance of the Orpheum is clearly visible, and not only is the Lyric Theatre shown but its Main Street sign appears in all three of the upper street photographs. The Lyric itself was several blocks east of Main Street. Madison Avenue, the center of commerce, had its set of new streetlights installed before Main Street did. (Courtesy of the Greater Memphis Chamber of Commerce.)

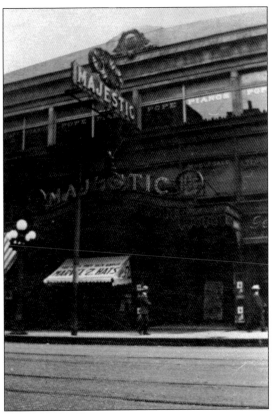

The New Majestic No. 2 was built by Frank Montgomery in 1913 and became known as the Strand in 1920. The wide canopy covers both the tiny entrance to the theatre and a storefront. Later marquees were only the width of the theatre entrance. (Courtesy of MPLIC, Pink Palace Collection.)

This photograph shows an early theatre family. The woman on the right is Bessie Phipps Cayman. Angela Estelle Garavelli Astor tells a story that she and Bud Cayman (the child Bessie is holding) used to sit in the Majestic No. 1 watching the movie while her mother Bessie Hill Garavelli and Bessie Cayman visited. Bessie was cashier at the Majestic and her husband (on the left) was projectionist. (Courtesy of Angela Garavelli Astor.)

The New Majestic Theatre No. 1 was opened in 1914 by Frank Montgomery and later owned by Bert Jordan. It outlasted all the other Majestics, but the advent of sound pictures signaled a major change. Rather than refit the theatre, the owner sold it to become a clothing store. It survived a succession of tenants and was restored in recent years. The facade lighting still operates. (Courtesy of MPLIC, Pink Palace Collection.)

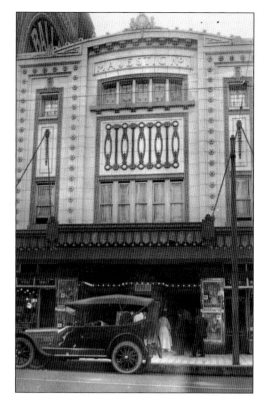

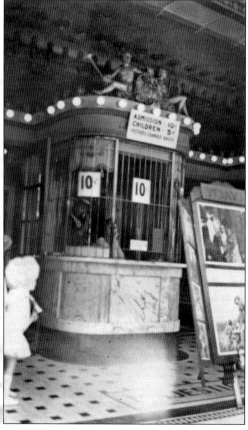

The elaborate box office of the Majestic No. 1 conceals the face of the cashier. It is possible that this is Bessie Phipps Cayman (later Jerome). Here, the name of the theatre can be seen in the tile floor, a feature of many early theatres. (Courtesy of MPLIC, Pink Palace Collection.)

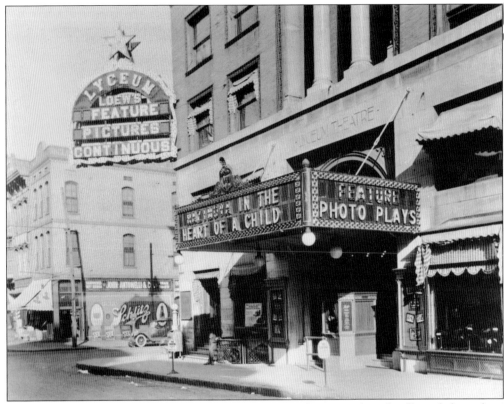

The Lyceum Theatre was leased to Loew's Inc. in 1916, and presented vaudeville and photoplays, among them *The Birth of a Nation*. Loew's eventually added the canopy and the name Loew's to the extant corner sign. The Lyceum Theatre showed strictly films for a time starting in 1920. (Courtesy of the Theatre Historical Society of America, Loew's Collection.)

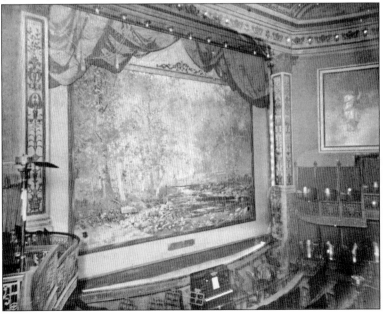

The Lyceum Theatre was very proud of its "all electric" lighting in 1894 and its many electric fans, some of which were mounted on poles in the "Golden Horseshoe" (first balcony) boxes. Both can be seen in this photograph from 1900 with the asbestos lowered. Also visible is one of the murals. (Courtesy of MPLIC.)

In 1920, the screen was the centerpiece of the Lyceum stage, with any live acts and even the orchestra having to share the space. A type of "photoplayer" (a player piano with organ pipes and percussions in the cabinets on either side) was installed in the tiny orchestra pit and required a double mirror for the musician to accompany the films. (Courtesy of the Theatre Historical Society of America.)

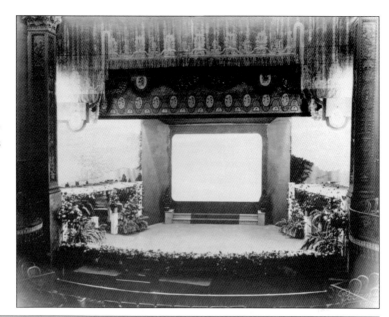

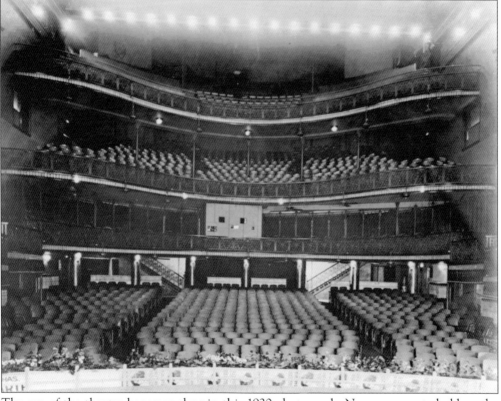

The age of the theatre becomes clear in this 1920 photograph. Numerous posts hold up the balconies, there are windows in the side walls of the auditorium for ventilation, the highest balcony appears to be mostly standing room, and the exposed electric lights are the primary lighting. The projection booth occupies some of the most expensive seats in the house. (Courtesy of the Theatre Historical Society of America.)

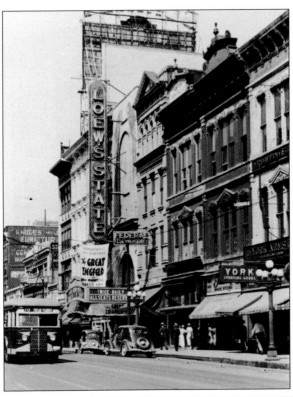

Loew's State Theatre, seen here in 1936, still has its original curved marquee and incandescent vertical. Loew's began construction of its two Memphis theatres in 1919. In early announcements, the theatre was to be called Loew's Metropolitan. It opened as Loew's State in October 1920. (Courtesy of the Theatre Historical Society of America, Loew's Collection.)

Much of the full length of the Loew's State Theatre building is visible here from the marquee on Main Street to the converted commercial building facing Second Street. A section was removed from a row of 19th-century storefronts on Main Street to connect the entrance to the auditorium building facing Second Street. (Courtesy of Memphis Heritage, Newman Collection.)

The William R. Moore Company owned this building facing Second Street and also a section of frontage on Main Street. The two buildings were connected by a second-story bridge so as not to block deliveries into the alley. This enabled the remodeled building to have a Main Street entrance. The sign reads "Loew's Leads in Memphis." (Courtesy of the Shelby County Archives.)

Less than a year after the photograph opposite was taken, the vertical and marquee were updated. This is the display familiar to many Memphians who have fond memories of Loew's State Theatre. (Courtesy of the Theatre Historical Society of America, Loew's Collection.)

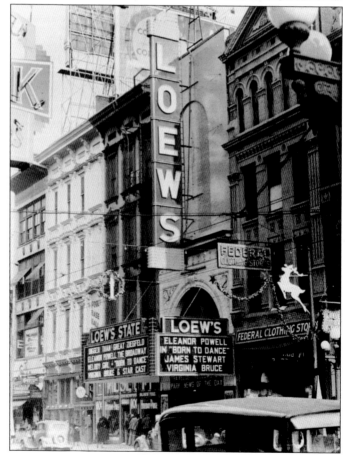

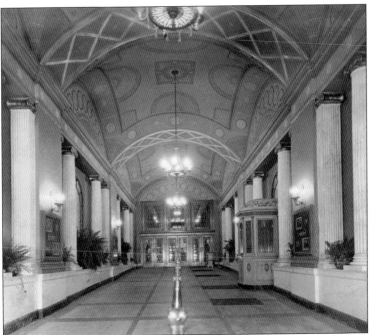

Loew's State Theatre's architect, Thomas Lamb, built several theatres that were connected to their entrances by long entryways. The well-remembered lobby of Loew's State had a second box office; Adam decor; tall, arched mirrors; and elaborate chandeliers. Through the doors in the center was a wide, white marble staircase to the bridge across the alley. (Courtesy of the *Commercial Appeal*.)

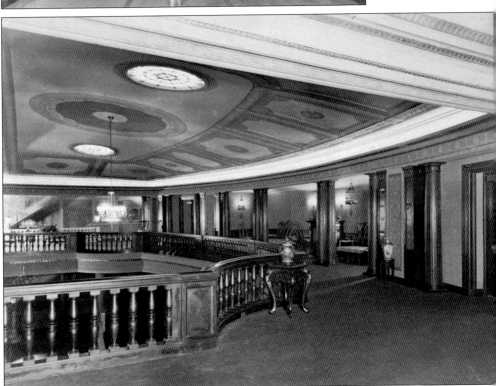

The white marble stairs led into this foyer and, in later years, directly to the concession stand. The foyer contained the upstairs lounges and the tunnel entrances to the balcony. Through the theatre's entire history, the balcony was always open and the main floor closed when there were few patrons—the opposite of most theatres. (Courtesy of the *Commercial Appeal*.)

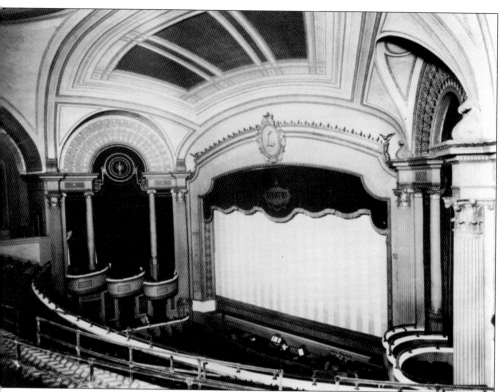

The auditorium contained traditional stepped boxes on both floors but otherwise was not highly ornate. The exit signs were of stained glass (and numbered) and much of the lighting, especially under the large balcony, was backlit stained glass. It felt very modern compared to the larger 19th-century theatres. (Courtesy of the Theatre Historical Society of America.)

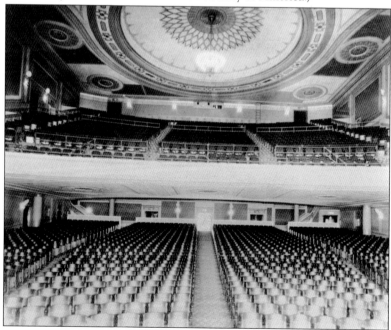

Most of the 2,500 seats are visible in this photograph of the balcony of Loew's State Theatre. The large plaster chandelier was also fitted with stained glass, and brass tripod light fixtures stood on the newel posts. The decor of the entire theatre changed very little throughout its history. (Courtesy of the Theatre Historical Society of America.)

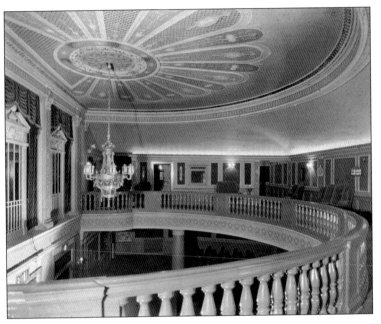

As the lobby of Loew's State Theatre was half a block long, the lobby of Loew's Palace Theatre was wide and shallow. The half-block depth of its lot had two alleys to avoid. The Palace, decorated in a similar Adam style by architect Thomas Lamb, was more ornate, and a windowed partition between the lobby and this foyer gave the illusion of more space. (Courtesy of the *Commercial Appeal*.)

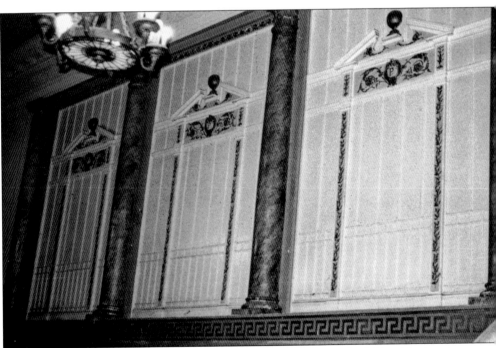

In 1977, the glass in the partition had been painted over. This is the lobby side showing one of the unique chandeliers. One just like it hung over the box office. *P* monograms are visible over the partition windows. *Ben-Hur* was shown at the Palace in 1925. (Courtesy of MPLIC.)

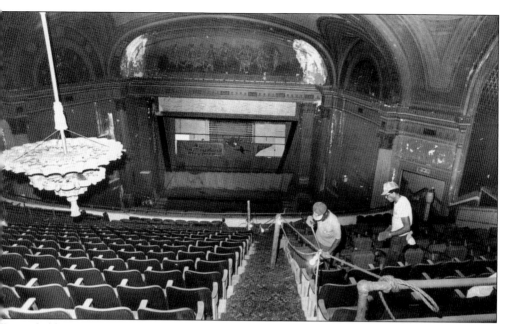

On early blueprints, the flat proscenium arch was planned as a half-dome, similar to the original Rialto Theatre in New York. This was changed and the mural took its place. Some of the ornamentation and the balcony chandelier are visible in this 1985 photograph. A number of the light fixtures were identical to Loew's State Theatre, and stained glass was also used throughout. (Courtesy of the *Commercial Appeal*.)

The facade and second display of Loew's Palace Theatre were beautiful in 1940. The theatre faced Union Avenue, around the corner from Main Street. CinemaScope and, for a time, Cinerama played the Palace. The installation of the Cinerama curved screen and equipment caused irreparable damage to the auditorium, and when it was removed, the Palace never was the same. (Courtesy of University of Memphis Library, Special Collections.)

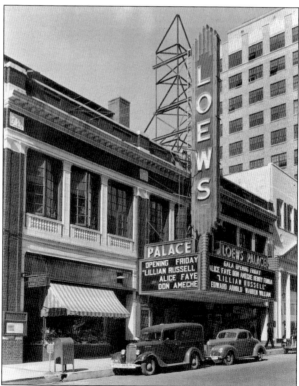

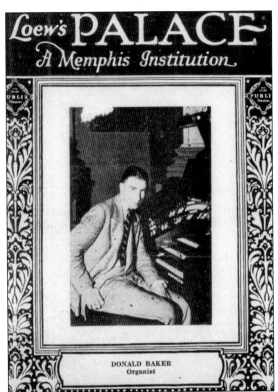

DONALD BAKER
Organist

Don Baker was an organist at Loew's Palace Theatre in 1926. He used his full name, Donald, while working in Memphis, but later became famous at the New York Paramount Theatre and had a long career. Well known in the silent movie era and during a revival of the theatre organ in the 1960s and 1970s, he also played many concerts on the Conn electronic organ. (Courtesy of Stan Hightower.)

M.A. Lightman Sr., who owned Malco Theatres, leased the Palace Theatre from Loew's in the late 1930s. This display from 1939 shows one of the deeply etched mirrors next to a staircase. Replicas of these mirrors now hang in the Orpheum. (Courtesy of Malco Theatres, Inc.)

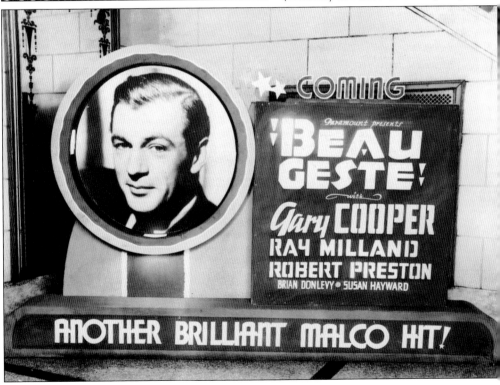

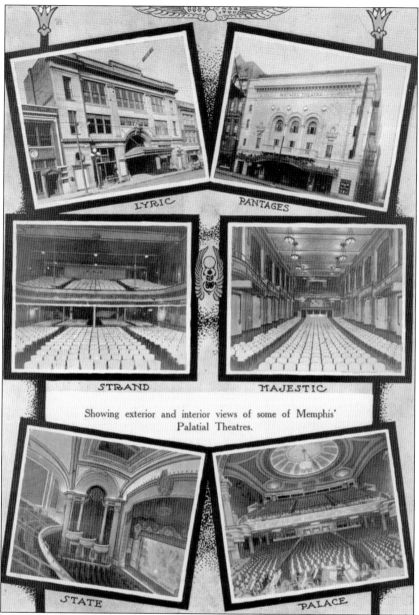

LYRIC PANTAGES

STRAND MAJESTIC

Showing exterior and interior views of some of Memphis'
Palatial Theatres.

STATE PALACE

This unusual set of photographs was published in a book called *Memphis: The Capital of the Mississippi Valley*, published in 1922. The book was intended as an overview of what Memphis had to offer. Images of banks, parks, churches, stately homes, fine stores, hotels, and many industries and businesses appear in this interesting promotional book. The interior photographs of the theatres are retouched to a great degree but offer rare glimpses inside the Strand, Majestic, and Palace Theatres. The Orpheum, Lyric, Lyceum, Pantages, and Loew's State Theatres are all listed elsewhere in the book as theatres. The Princess, Strand, Majestic, and Loew's Palace Theatres are listed as movie houses. It is the three newer theatres that are emphasized here. The Orpheum, Lyceum, and Princess Theatres were all still operating and still palatial, but do not appear here. Possibly the Orpheum Theatre and Lyceum Theatre buildings looked too antiquated. (Courtesy of the Shelby County Archives.)

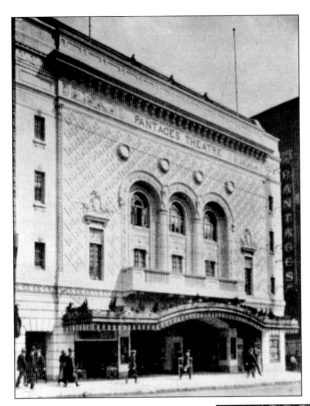

After several years of planning, the Pantages Theatre opened to great fanfare in 1921. Alexander Pantages, who owned a chain of theatres on the West Coast, had wanted to enter the Memphis market for several years. He engaged architect B. Marcus Priteca to build an ornate theatre on a half-block lot with both a side and a back alley. (Courtesy of the Theatre Historical Society of America, Terry Helgesen Collection.)

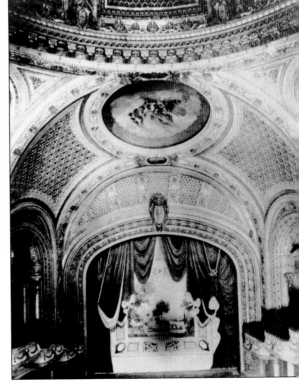

The Pantages was the most ornate theatre ever constructed in Memphis. The proscenium arch was a true, reinforced concrete arch, as shown by the asbestos in the photograph. The mural was painted by Anthony Heinsbergen as his first assignment for Priteca. He would later decorate many more of his theatres. (Courtesy of the Theatre Historical Society of America.)

The scale can be guessed by the five-foot plaster urn seen in the center. It is the largest remaining artifact from the Pantages. The shallow lot did not allow for a grand lobby. Though the entry foyers were not large, they were equally ornate. The open entry at the box office was later enclosed for the concession stand. (Courtesy of the Theatre Historical Society of America.)

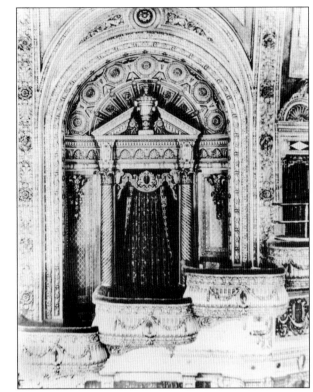

Ornamentation covered almost every square inch of the Pantages, and the theatre was primarily lit by indirect lighting and the stained-glass fixture in the center of the dome. The ribs of the dome were also reinforced concrete. (Courtesy of the Theatre Historical Society of America.)

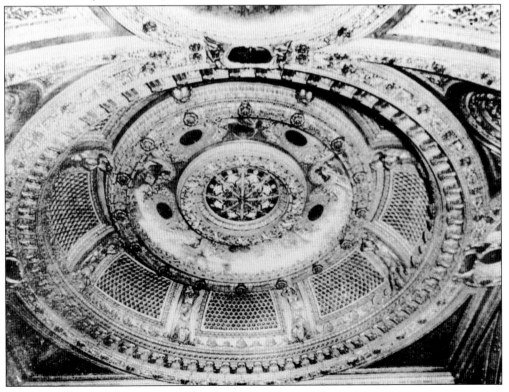

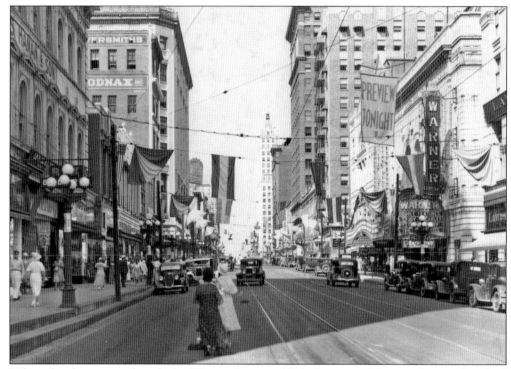

When the theatre was bought by Warner Bros. in 1929, the most elaborate theatre then had the most elaborate marquee. The gleaming white terra-cotta facade of the Warner appeared in countless photographs throughout its history. This is a view of a busy Main Street in 1936. (Courtesy of MPLIC.)

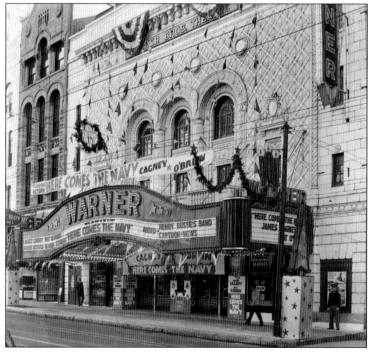

The marquee has been modernized and streamlined but is still the most outstanding and brightest. It is Christmastime, and the film is a revival from 1934. Another film is mentioned on an exit door—*The Long Voyage Home*, which was released in 1940, as was the short subject on the marquee featuring Henry Busse's band. (Courtesy of Richard Brashear.)

Two

MAIN AND BEALE

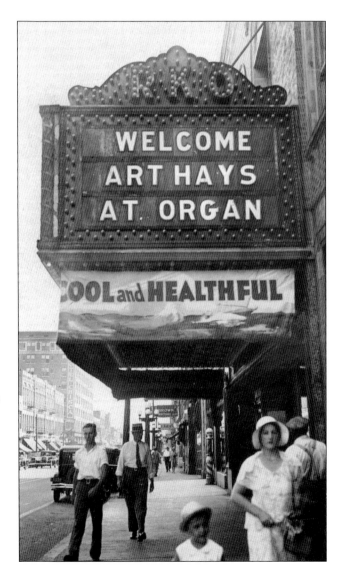

For a very short time, the Memphis Orpheum Theatre was the RKO Orpheum. Radio-Keith-Orpheum was coined when the Keith-Albee-Orpheum circuit of vaudeville theatres merged with Joseph Kennedy's film studio, which then became RKO Studios. The end of the marquee (already repainted in 1929) has the "RKO" attached over the scroll display. The theatre circuit went bankrupt in 1933, and the Memphis theatre returned to private ownership. (Courtesy of Carolyn Hays.)

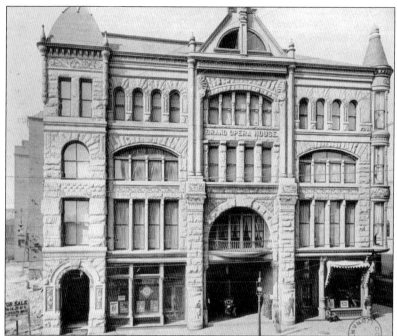

In 1895, the Grand Opera House was still in the first flush of success. It was faced with blue Bedford stone, seated 2,329, and had four stories of rental spaces in front. Playing is *In Old Kentucky,* an 1893 play by Charles T. Dazey that was made into a film in 1919 and again in 1927. Will Rogers was the star of a sound version in 1935. (Courtesy of MPLIC.)

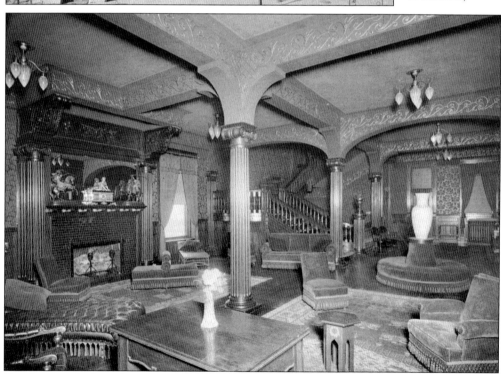

No photographs have been located of the interior of the Grand Opera House, but a few exist of the club rooms of the Chickasaw Guards, also housed in the building, that give an idea of its 19th-century opulence. The Chickasaw Guards was a competition drill unit organized in 1874. It toured and raised money to aid in fighting yellow fever and had a national reputation. (Courtesy of MPLIC.)

This image from *Night in Memphis*, 1911, shows a classic view of the corner of Main and Beale Streets. Close inspection reveals the curved window screens used on the pivoting upper windows. The crescent-shaped "Theatre" sign on the Columbia is just past Beale and its front is edged with lights. (Courtesy of MPLIC.)

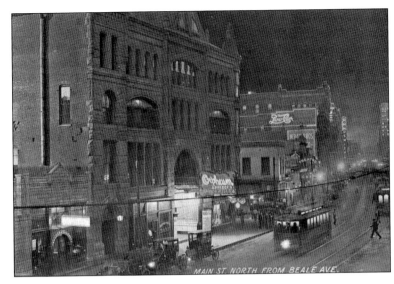

MAIN ST. NORTH FROM BEALE AVE.

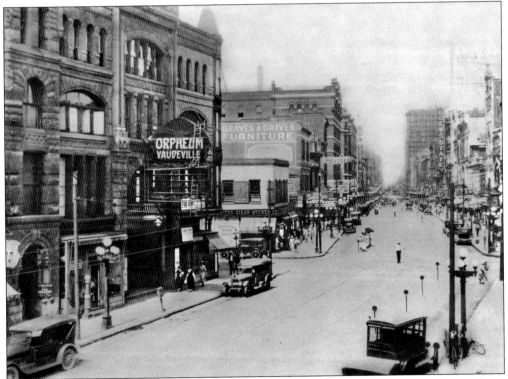

Ten years later, new streetlights have been installed, Loew's State Theatre has opened, signs have appeared and disappeared, and autos are more numerous. The pivoting windows are clear in the daylight and the Orpheum Theatre has a new changeable sign. Main Street curves to the west at Beale Street, so the corner building had to have a large sign to be seen from the north. (Courtesy of University of Memphis Library, Special Collections.)

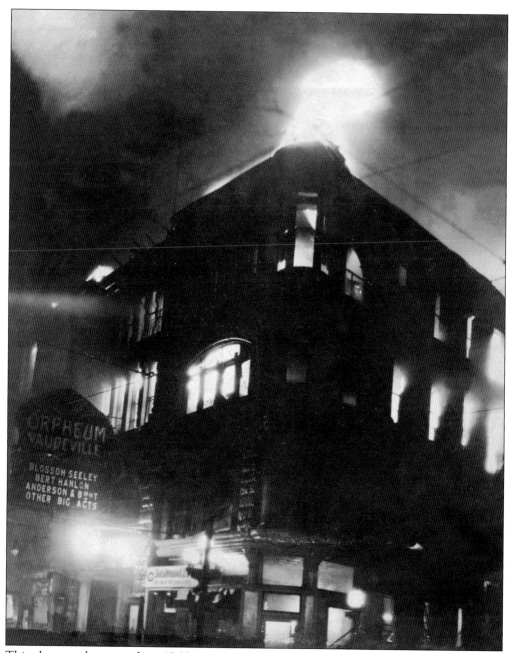

This photograph was made at 12:02 a.m., October 17, 1923, while the Orpheum Theatre blazed and firemen fought desperately to save it. The loss was valued at more than $250,000. The fire was the most spectacular seen in Memphis in years. It was watched by the largest crowd in the history of the theatre. The fire started in the Tri-State Manufacturing Company, which made clothing, in the upper commercial section. Legend has it that balcony patrons felt especially warm toward the end of the last show. There was no loss of life, but many of the performers lost valuable props and costumes. Blossom Seeley's wardrobe was rescued by stagehands (Chalmers Cullins among them). According to a story told by Cullins, her gratitude was not very sincere. It is unclear what Bert Lahr, also on the bill, rescued or lost. (Courtesy of the *Commercial Appeal*.)

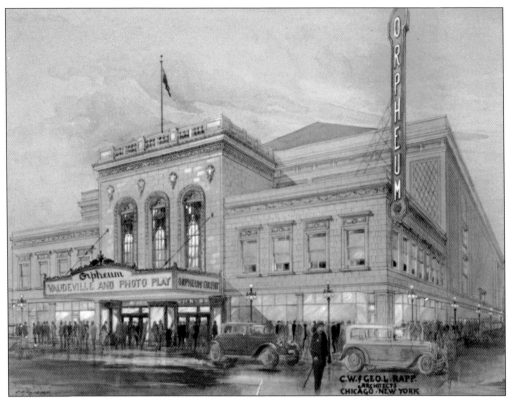

It took several years to replace the Orpheum Theatre, and Chicago architects George L. and C.W. Rapp were commissioned to design the new theatre. This rendering, signed C.F. Frybort, is in a restrained style and is very optimistic about the new building's symmetry. The watercolor rendering came to the theatre many years later. (Courtesy of the Orpheum Theatre.)

The New Orpheum Theatre stood proud and shining in late 1928. The street frontage of the Grand Opera House was narrower than its auditorium. To finish the design of the front, additional property south of the entrance had to be purchased and was added after the main building was already begun. All the commercial sections were attached to the lobby in 1983. (Courtesy of the Theatre Historical Society of America.)

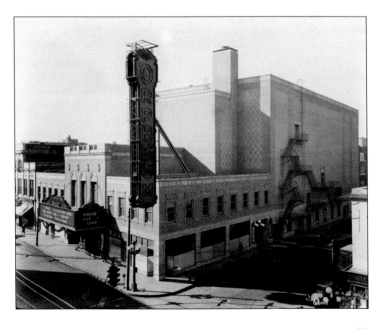

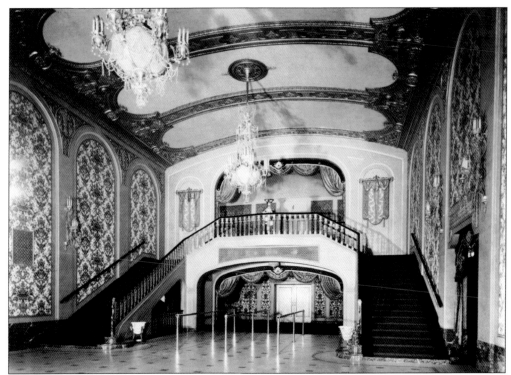

The New Orpheum Theatre had the most spacious lobby of all the downtown theatres and the grandest staircase. There was room for elaborate chandeliers and large displays to promote shows and films. The theatre had an elevator, centrally chilled water fountains, a central vacuum system, and the latest in air-conditioning. (Courtesy of the Theatre Historical Society of America, Chicago Architectural Photographs Collection.)

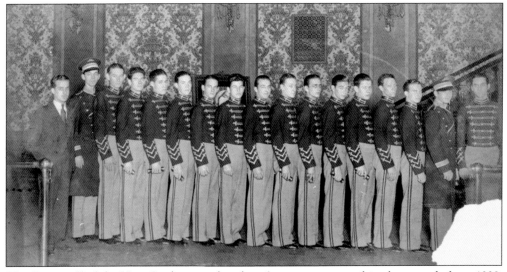

The floor staff of the New Orpheum is lined up for inspection in this photograph from 1929. Dr. George Hays, son of organist Art Hays, is in uniform on the far left next to the streetman in the hat. The streetmen opened doors and assisted people into the entrance. The brocade wall covering was in use until 1982. (Courtesy of Carolyn Hays.)

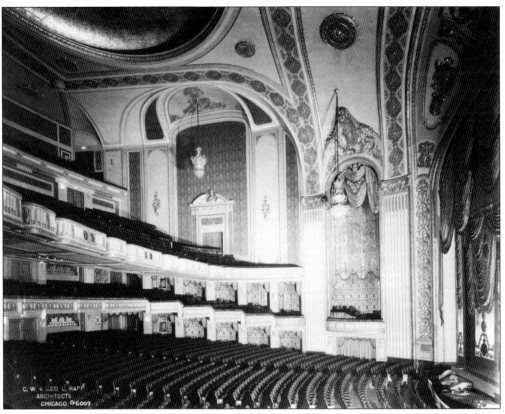

The auditorium seated over 2,700 people on five levels. This view is of the south side and shows most of the decorative treatments. Late in construction, the orchestra pit was made smaller to add another row of seats. The wooden floor beneath was not rediscovered until 1982, when a larger pit was needed for *Hello, Dolly*. (Courtesy of the Theatre Historical Society of America.)

The main lounge was very different from the upper levels. It was decorated and furnished in Art Deco, with original art prints, a checkroom, telephones, and a separate exhaust system for smoking rooms. The center table, water fountain, art, and etched-glass light fixtures are still in place. (Courtesy of the Theatre Historical Society of America/ Orpheum Theatre.)

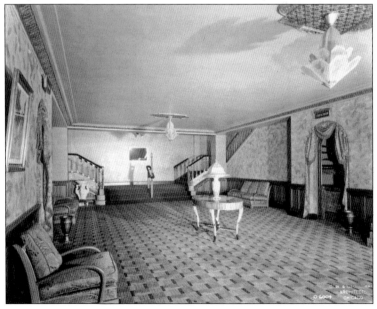

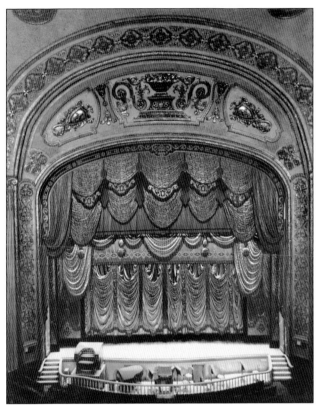

The proscenium drapery was very elaborate and made the oblong opening appear a graceful arch. The console of the Wurlitzer organ is seen on its lift in the solo position. This was the only console in Memphis with a performance lift. The lights are from Border No. 1, which lit some of the solo acts that did not require sets and played "in one" in front of the main curtain. (Courtesy of the *Commercial Appeal*.)

The Orpheum Theatre ushers were sometimes part of the promotion. George Hays is one of the two tall ushers in the center, on the right. *The Dawn Patrol* (1930) was a talkie with an aviation theme. (Courtesy of Carolyn Hays.)

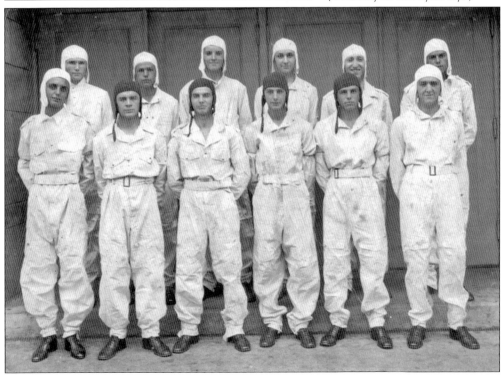

The Orpheum's vertical also carried the "RKO" letters and has been repainted in an elaborate Moderne pattern. The sign came equipped with means to hang advertising such as seen here. In 1931, the most expensive evening ticket price was 40¢. Art Hays at the organ was a major draw. (Courtesy of Carolyn Hays.)

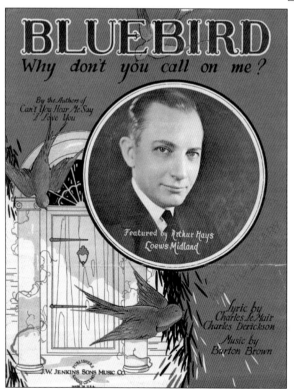

Performers were frequently pictured on sheet music of songs they promoted. Here is one featuring Art Hays during his time at Loew's Midland Theatre in Kansas City, Missouri. He also worked for Loew's Palace Theatre in Memphis in the early 1930s. (Courtesy of Carolyn Hays.)

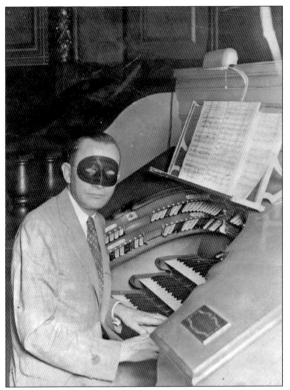

In the July 20, 1930, edition of the *Commercial Appeal*, a mystery organist is shown at the console of the 3-manual, 13-rank Wurlitzer organ at the Orpheum Theatre. This organist broadcast over WMC radio in Memphis every Sunday afternoon. This is again Art Hays, who played the smaller Loew's Palace Theatre Wurlitzer, and was broadcast playing the larger and newer Orpheum Theatre organ. (Courtesy of Carolyn Hays.)

Memphis had a number of blue laws in the 1930s that prohibited movie theatres from opening on Sunday. This photograph from June 18, 1934, shows a sandwich counter in the Orpheum lobby. The movie was free with the purchase of a sandwich. The theatre managers argued that if the hotels could have orchestras to entertain guests, why couldn't the theatres have films? (Courtesy of the *Commercial Appeal*.)

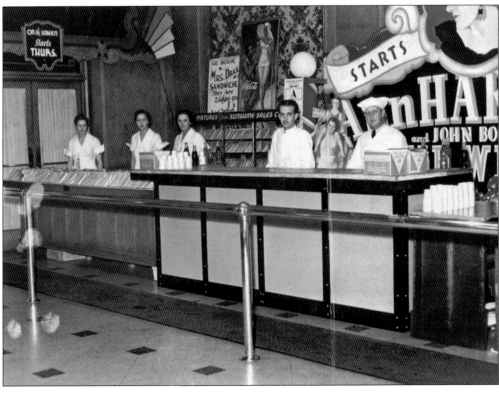

First the Orpheum and then the other large theatres tried these tactics and paid the resulting fines. Eventually, the theatres were allowed to open and the Orpheum tried various types of shows to stay afloat. Fan dancer Sally Rand and Jimmy Lunceford with his band played on the same program with films. (Courtesy of the *Commercial Appeal*.)

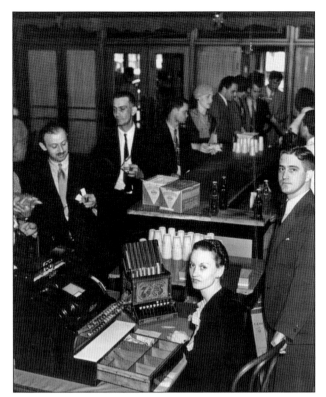

This view of Main Street, south of Gayoso Avenue, was taken in 1939. The same four theatres visible in the cover photograph may be seen here—three with earlier outdoor displays such as the Strand Theatre on the left, the Princess Theatre on the right, and the Orpheum Theatre vertical. (Courtesy of Memphis Heritage, Newman Collection.)

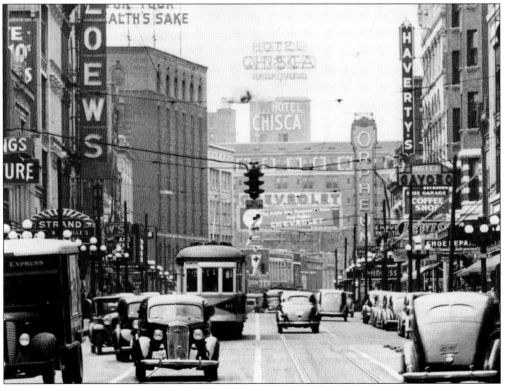

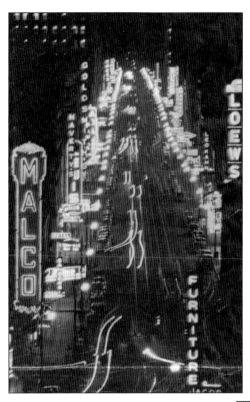

The view from Main and Beale Streets has changed again. Neon has appeared everywhere and the Orpheum Theatre's vertical now reads "Malco." The Orpheum building was purchased after foreclosure and reopened in 1940 by M.A. Lightman Sr., becoming the flagship of his company, Malco Theatres, Inc. (M.A. Lightman Company). (Courtesy MPLIC.)

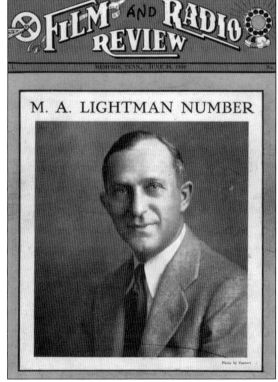

This *Film and Radio Review,* published June 30, 1930, is dedicated to M.A. Lightman Sr. He entered the theatre business in Alabama in 1915. By 1930, he owned a number of theatres in Arkansas, West Tennessee, Louisiana, northern Mississippi, western Kentucky, and southeastern Missouri. It was in 1929 that Malco Theatres purchased its first location in Memphis, the Linden Circle Theatre. (Courtesy of Malco Theatres, Inc.)

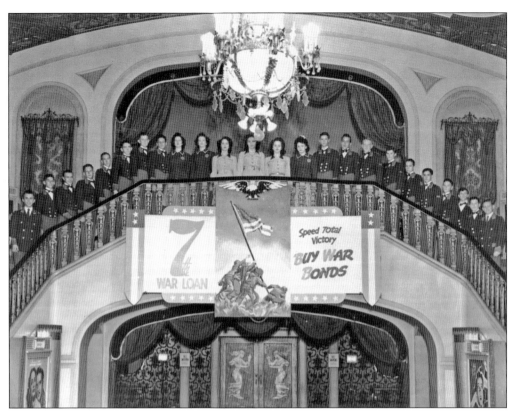

The staff of the Malco Theatre was photographed on the lobby staircase in 1945. Large displays hanging from the center of the stairs have appeared. Coming attractions appear to be A Medal for Benny with Dorothy Lamour (1945) and The Uninvited with Ray Milland and Ruth Hussey (1944). The figures painted on the center doors do not appear in earlier or later views of the lobby. (Courtesy of Malco Theatres, Inc.)

The beautiful console table and mirror visible in the upper image are still in the theatre in 2013. The Albert Pick Company supplied some of the furnishings, a number of which are still in use. This photograph was taken in the mid-1970s. (Photograph by Stan Hightower, courtesy of the author.)

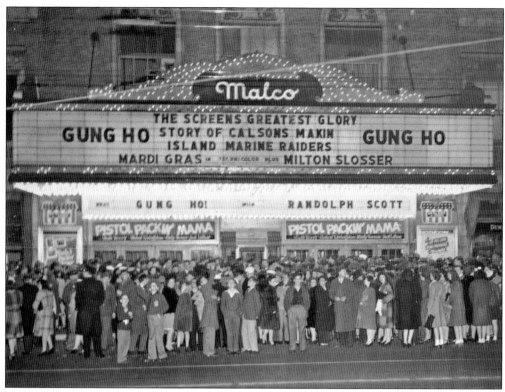

The signs advertise the Fourth War Loan Bond Premiere in 1943, and there is a variety of titles and coming attractions. The famous organist throughout the war years was Milton Slosser, whose talent and sing-alongs were remembered by that generation for many years thereafter. (Courtesy of Malco Theatres, Inc.)

Milton Slosser had a long career as a theatre organist playing at a number of theatres. He is most closely associated with the Ambassador Theatre in St. Louis, the Ritz in Tulsa, and the Malco in Memphis. This photograph is inscribed to Art Hays. Hays and Slosser are the primary organists who are remembered before the organ's revival in 1969. (Courtesy of Carolyn Hays.)

Patrons line up for a double feature and a war bond premiere. The film is *Destroyer*, starring Edward G. Robinson; *Let's Face It*, with Betty Hutton and Bob Hope, appears to be a second feature. The banner board advertises "Big Acts on Stage" for this preview in 1943. (Courtesy of Malco Theatres, Inc.)

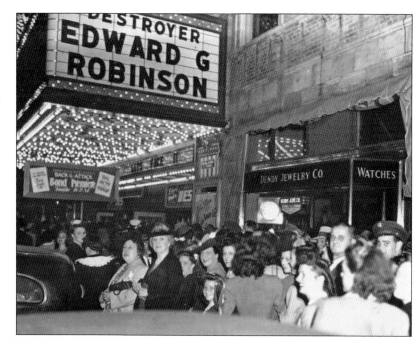

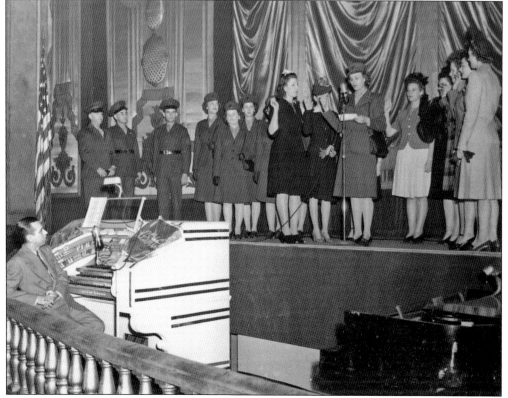

Milton Slosser is seated at the Malco Theatre organ during one of the bond drives during World War II (1943). The elaborate stage curtains are still beautiful here; unfortunately, an accidental fire destroyed them in 1957. (Courtesy of Malco Theatres, Inc.)

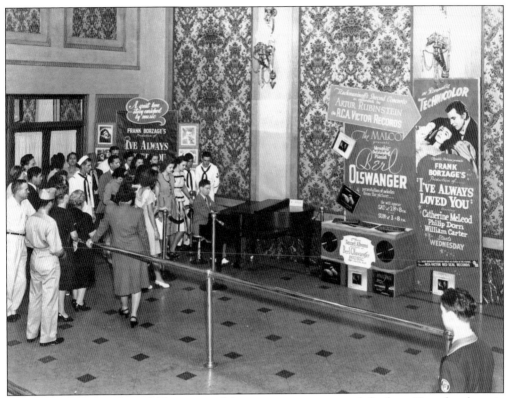

The Malco Theatre's large lobby was used for many promotions and displays. Here, local music store owner Berl Olswanger promotes the next picture, *I've Always Loved You* (1946), by performing music from the sound track. Catherine McLeod's role as a concert pianist is considered her finest. A signature piece in the film is Rachmaninoff's Second Piano Concerto recorded by Arthur Rubenstein; Olswanger had records available. (Courtesy of Malco Theatres, Inc.)

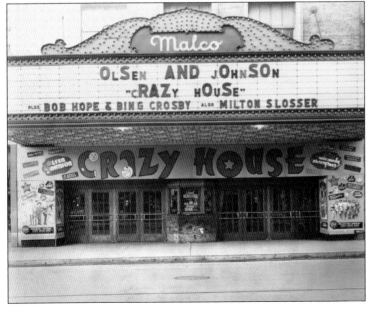

Promotions also extended to the exterior, as in this 1943 display for *Crazy House*, starring comic team Olsen and Johnson (Bob Hope and Bing Crosby in *Don't Hook Now* are a footnote). False fronts that hung over the box office were a trademark of the theatre until the 1970s. The numerous comedians and bands appearing in the film seem like vaudeville has returned—on the screen. (Courtesy of Malco Theatres, Inc.)

Three

"COLORED" BALCONIES, "COLORED" THEATRES

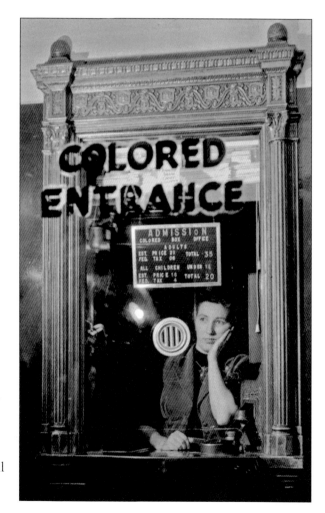

"Jim Crow dictated separate entrances for whites and blacks at Memphis theatres, such as the Malco, at Main & Beale, in 1954," writes Robert Williams in the *Commercial Appeal*. This was taken on or about January 8. Pictured is Ruth Priest, 27. The term *colored* will be used throughout in its correct historical context. It was considered the proper and respectful term during this time. (Courtesy of the *Commercial Appeal*.)

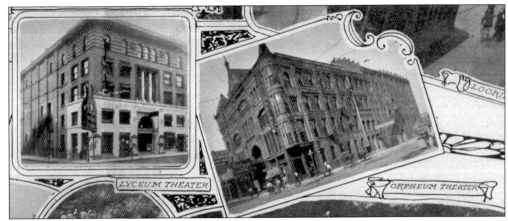

The Orpheum Theatre's side entrance, with its illuminated sign, can be seen in this photograph from 1913. A story told by Chalmers Cullins, an Orpheum employee, relates that Julia Hooks, a pioneer civil rights activist, refused to sit in the "colored" balcony during one of Sarah Bernhardt's performances. She was finally sold an orchestra seat. This implies that the building had a separate balcony and entrance. (Courtesy of the Greater Memphis Chamber of Commerce.)

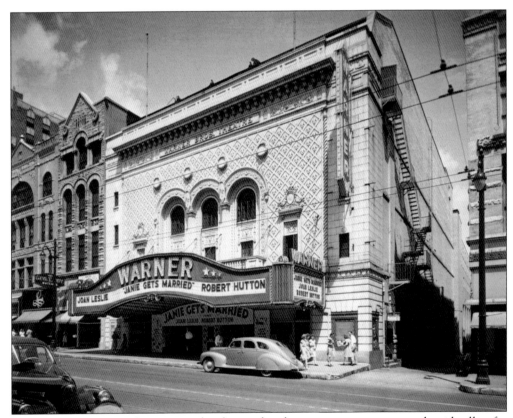

The Warner/Pantages Theatre was also designed with a separate entrance, on the side alley, for "colored" patrons. The tiny sign is visible here in 1946. The fire escape shows the height of the balcony though the actual entry staircase was inside. It is unclear whether the Lyric or Lyceum Theatres had separate accommodations. (Courtesy of Memphis Heritage, Newman Collection.)

This enlargement clearly shows the "Colored Entrance" sign. All patrons bought tickets at the same main box office. Seats were usually cheaper than the lower floors. Neither of the two Loew's Theatres had separate entrances or balconies. (Courtesy of Memphis Heritage, Newman Collection.)

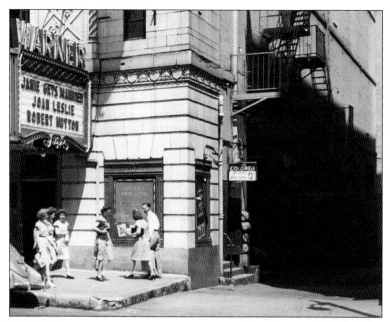

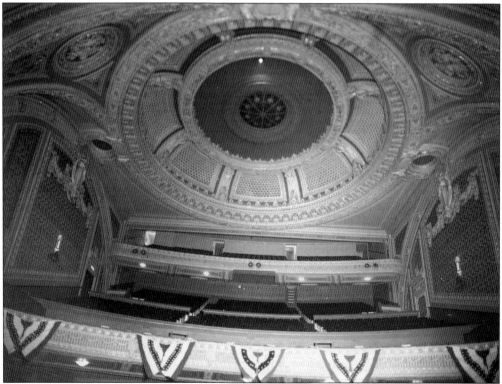

The interior of the Warner Theatre was redone after it was purchased from Alexander Pantages. The separate balcony is at the top in this 1943 photograph, even over the projection booth. These balconies were known by many names—"peanut gallery" was one of the more common. "Colored Balcony" was considered proper. The Warner's balcony has been described as "not posh." (Courtesy of MPLIC.)

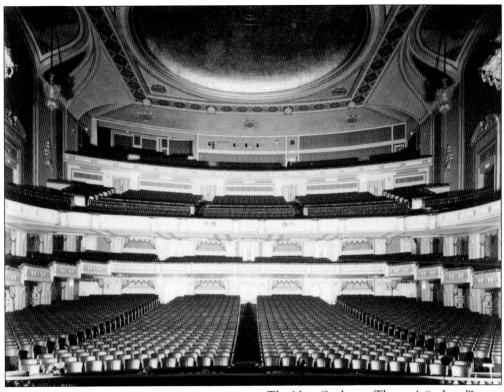

The New Orpheum Theatre's "colored" balcony, due to the odd shape of the original lot, had seven extra rows on one side only. The foyer, restrooms, and appointments were identical to the lower floors. Two fire doors led to the side staircase (and the street) from the large balcony below. This enabled the two balconies to be connected when the separated area was enlarged and a partition divided the big balcony. (Courtesy of the Theatre Historical Society of America.)

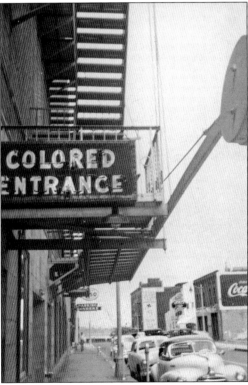

The "Colored Entrance" sign of the Malco/Orpheum Theatre was neon in 1953. The Orpheum's side box office was ornamented exactly like the main box office (see beginning of chapter). The box office photograph was taken through the entrance door, which makes the large lettering off-center from the window. (Courtesy of the Wisconsin Historical Society—image 83204, Lloyd Barbee Collection.)

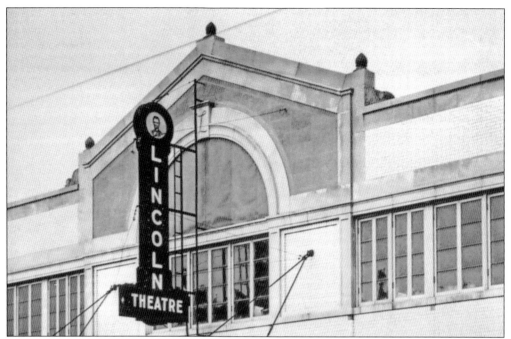

There were three Lincoln Theatres—one was this theatre on North Main Street (seen here in 1927), another on Beale Street, and a later drive-in. Another photograph of this theatre shows a banner that reads "Entrance for White" (and it had a balcony), which implies this theatre served both communities. Alfred Suzore acquired the Lincoln Theatre in 1932. The theatre was then known as Suzore's No. 2. His No. 1 was on Jackson Avenue. (From a private collection.)

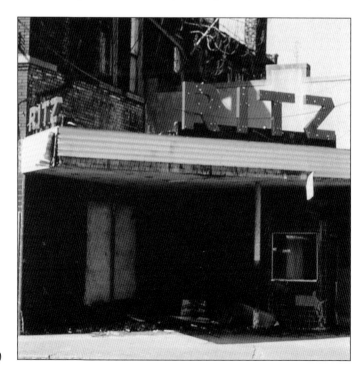

Dave Lebovitz owned and operated several "colored" neighborhood movie theatres: the Ritz (1958, opened as the Ace in 1927), the Harlem (1934, opened as the Gem in 1926), and the Georgia (1939). The Lebovitz brothers later owned the Sky-Vue and Lamar drive-ins. The auditorium of the Ace/Ritz was in a large building to the left of this entry. (Courtesy of www. americanclassicimages.com.)

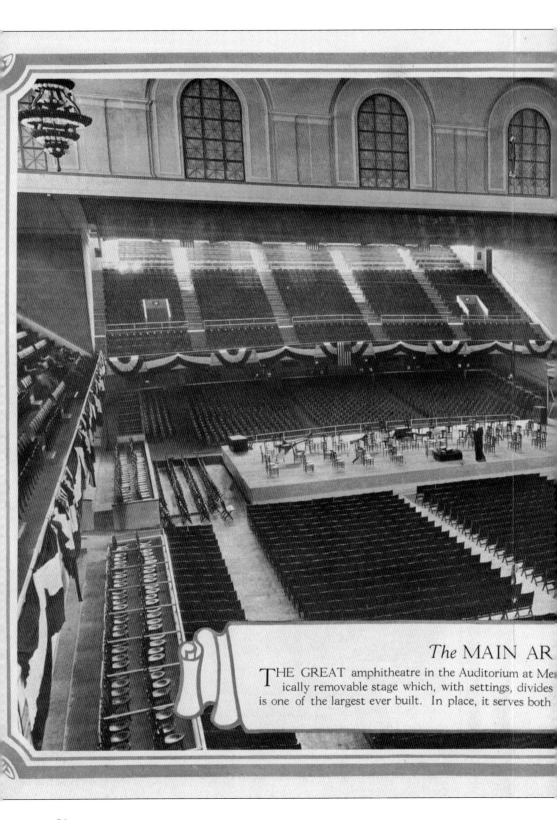

The MAIN AR

THE GREAT amphitheatre in the Auditorium at Me
ically removable stage which, with settings, divides
is one of the largest ever built. In place, it serves both

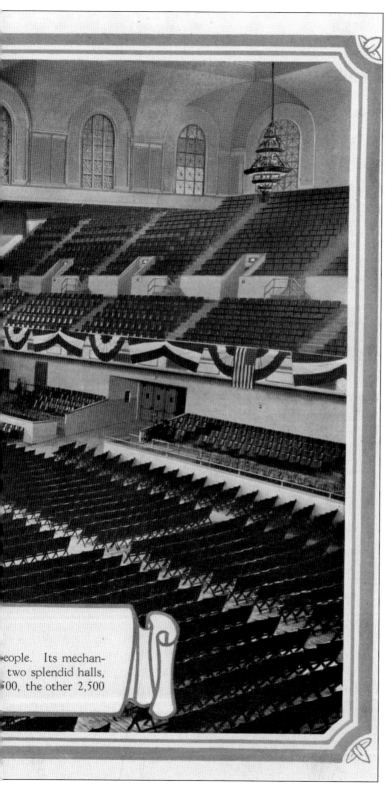

eople. Its mechan-
two splendid halls,
00, the other 2,500

The Ellis Auditorium (1924) was multipurpose. The platform in the center is the stage floor, installed on lifts. When used as a stage, proscenium arches could be lowered in both halls, and a soundproof curtain was later installed so two events could be held simultaneously. When these arches became permanent, the unused seats on stage left and right were visible backstage. The auditorium also contained a 115-rank, dual console Kimball concert organ with divisions serving both halls. Both organs still exist. The south hall (seen here from the north hall side, behind the stage platform) was equipped with motion picture projectors. Its primary contribution to movie history was a weeklong run of *The Jazz Singer* with Al Jolson and several other early talking pictures before the other theatres had been outfitted for sound. (Courtesy of Karen and Bob Fleming.)

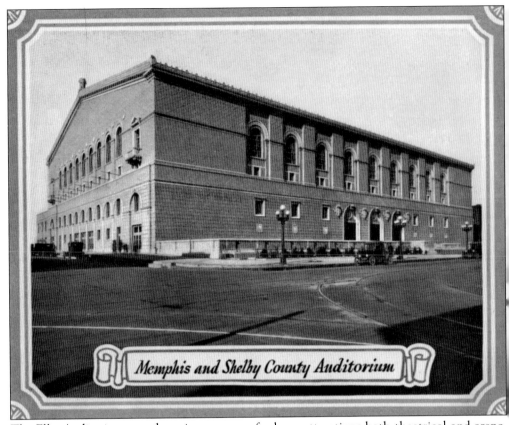

Memphis and Shelby County Auditorium

The Ellis Auditorium was the primary venue for large attractions both theatrical and arena. Sporting events, circuses, and ice shows alternated with local symphony and the Metropolitan Opera tour. Its career began with John Philip Sousa (1924) and ended with Bruce Springsteen (1996). An enclosed farmers market, meeting rooms, and the latest in equipment were part of its amenities. It contained a "colored" balcony in each of its two halls. (Courtesy of MPLIC.)

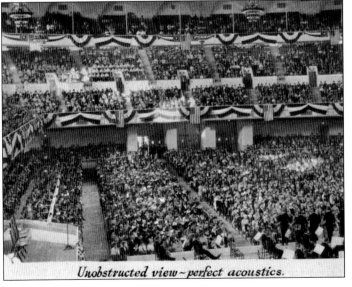

Unobstructed view ~ perfect acoustics.

During this concert, the amphitheatre in the north hall is filled almost to capacity and the "colored" balcony is in use. It is partially suspended by rods and its entrance was separate. The smaller south hall had a similar balcony, also partially suspended. In 1959, when a larger lobby was added on Main Street, the separate entrances became difficult to find. (Courtesy of Karen and Bob Fleming.)

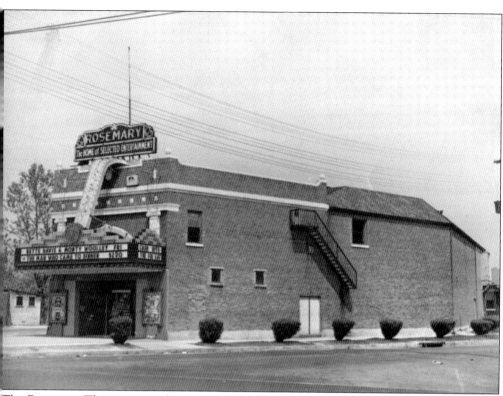

The Rosemary Theatre opened in 1929 and was built by Michael Cianciolo Sr. It stood on a pointed lot at Cleveland Street and Jackson Avenue. The separate "colored" entrance was on the other side, and both communities used the same box office. Its elaborate neon display was unrivaled until the Crosstown Theatre opened decades later several blocks further south. (Courtesy of Michael Cianciolo.)

The interior of the Rosemary Theatre was more elaborate than most of the neighborhood theatres. There were three Cianciolo sisters: Rosemary, Lucy, and Ann. Another one of their theatres was named the Luciann Theatre. The Rosemary stood until 1964 and its last film was *A Hard Day's Night,* starring the Beatles. (Courtesy of Michael Cianciolo.)

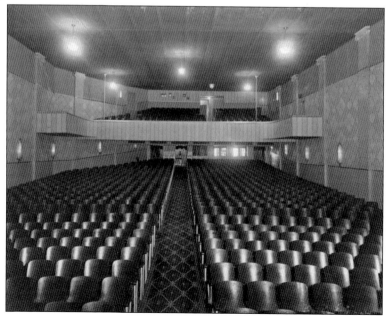

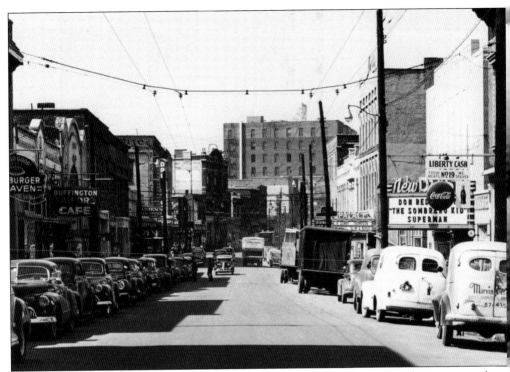

Here is a quiet daytime moment on Beale Street with all three theatres visible. The marquees of two can be seen on the right and the front of the Daisy Theatre on the left. The New Daisy Theatre was built in 1941 and replaced two older theatres that stood on the site. The New Daisy advertises movies, while the Palace Theatre advertises live acts. (Courtesy of Memphis Heritage, Newman Collection)

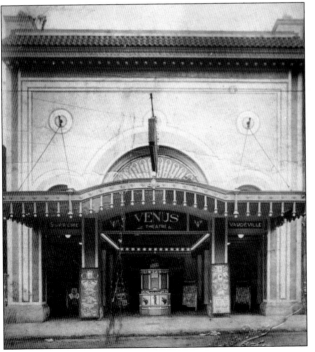

This theatre, one of those replaced by the New Daisy, operated under three names—the Metropolitan, Venus, and the New Grand. Anselmo and Gennaro Barrasso, Joe Maceri, Sam and Paul Zerilla, and Nello, Lorenzo, and Angelo Pacini all built and owned the various theatres on Beale Street. The Palace was the largest "colored" variety theatre in the South. (Courtesy of MPLIC.)

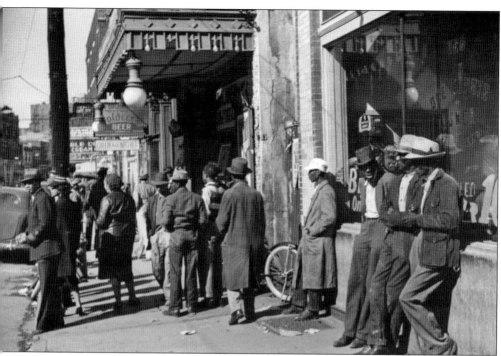

In October 1939, Marion Post Wolcott took these two photographs on Beale Street of a scene outside the Palace Theatre. The theatres on Beale all had stages and live acts, with the Palace being the best known. On its circuit, it was the equivalent of what Broadway's Palace Theatre had been to Orpheum vaudeville. (Courtesy of the Library of Congress, Prints & Photographs Division, FSA/OWI Collection.)

This young man is eager for one of the Westerns, but the Palace was more popular for its live entertainment than its films. The entertainers had local and national reputations, and there were "whites only" performances (the Thursday Night Midnight Rambles). After the stage show, there were times the theatre was empty for the last film of the evening. (Courtesy of the Library of Congress, Prints & Photographs Division, FSA/OWI Collection.)

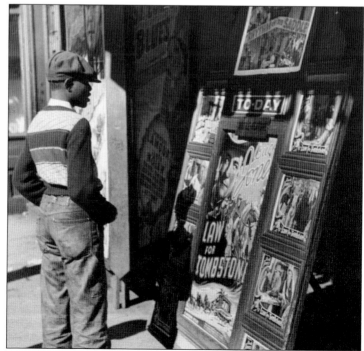

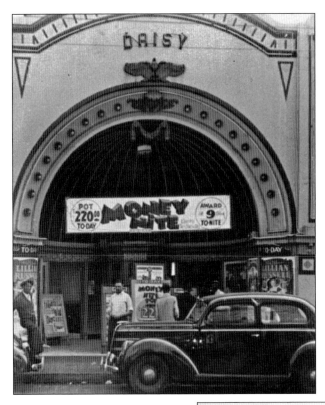

The Daisy Theatre was the most unique theatre on Beale Street. Opened in 1912, it was constructed between two existing buildings but had a small balcony. The fire escapes from this balcony had to be on the back alley. Therefore, the stage and screen were behind the box office and one entered the theatre looking at the balcony and projection booth. It had no lobby. (Courtesy of the *Commercial Appeal*.)

Chalmers Cullins was one of the busiest theatre people in town. He had worked backstage at the first Orpheum Theatre, leased the New Orpheum Theatre for a time, and was partner in the Savoy, Idlewild, and W.C. Handy Theatres. The Savoy Theatre on North Thomas Street was "colored" and the Idlewild Theatre on Madison Avenue was white. Cullins was highly regarded in both communities. (University of Memphis Library, Special Collections.)

Nate Evans was Cullins's partner in many ventures as well as the bandleader at the Orpheum Theatre. They brought Louis Armstrong, Jimmie Lunceford, Duke Ellington, and Count Basie to the Orpheum, and crowds from both communities overflowed into the aisles. Evans is to the left of W.C. Handy at the grand opening of the W.C. Handy Theatre. His son Irving is to his right. (Courtesy of Irving Evans/Center for Southern Folklore.)

Kemmons Wilson operated movie theatres before he founded the first Holiday Inn. The W.C. Handy Theatre opened in 1947 with Chalmers and Edward Cullins, Nate Evans, and Kemmons Wilson as partners. It had a similar format to the Palace Theatre on Beale Street, but was larger and newer and in the Orange Mound residential community. Handy performed there more than once. (Courtesy of Kemmons Wilson Companies.)

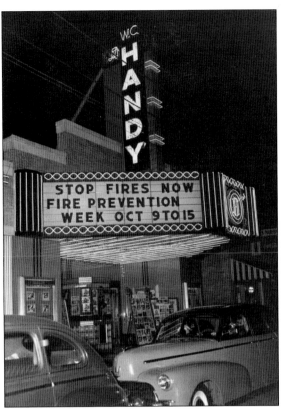

The W.C. Handy Theatre was fully equipped for both film and live entertainment. To augment the concession stand, a door led to an ice cream parlor right off the lobby. An article in the *1947–1948 Theatre Catalog* notes the stage "would accommodate a large band. . . . Three color footlights are provided and two rows of drops." Performers' dressing-room and toilet facilities were under the stage. (Courtesy of Memphis Fire Department Archives.)

Following the success of the New Daisy and W.C. Handy Theatres, the Palace Theatre was completely remodeled by 1950. The building was shortened and updated to complement the two newer buildings alongside. The Palace closed in 1962 and later was considered too dilapidated to restore. The Handy was open as a theatre, then as a club until 1984. After years of failed efforts at rehabilitation, it was demolished in 2012. (Courtesy of MPLIC.)

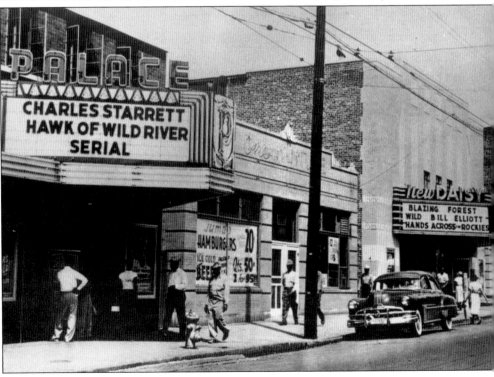

Four

COMING TO YOUR
NEIGHBORHOOD THEATRE

Sonja Bailey, 12-year-old daughter of Mr. and Mrs. C.W. Bailey of 2013 Young Avenue, was awarded a Shetland pony and Roy Rogers bridle and saddle in August 1951 as grand prize winner in the 10-week amateur contest held every Saturday at the Lamar Theatre at 1776 Lamar Avenue. She did a pantomime impersonation of Carmen Miranda, complete with costume. The contest sponsor was the Veterans Cab Company. (Courtesy of the *Commercial Appeal*.)

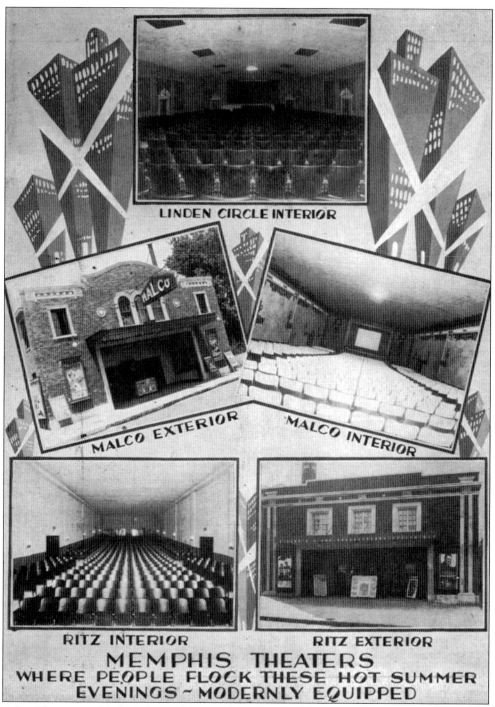

LINDEN CIRCLE INTERIOR

MALCO EXTERIOR

MALCO INTERIOR

RITZ INTERIOR

RITZ EXTERIOR

MEMPHIS THEATERS
WHERE PEOPLE FLOCK THESE HOT SUMMER
EVENINGS ~ MODERNLY EQUIPPED

Malco Theatres published these photographs of its neighborhood theatres in 1930. Its first Memphis theatre was the Linden Circle Theatre (1926), which Malco began operating in 1929. It owned the Malco Theatre shown in the center and later renamed it the Memphis. The theatre was completely remodeled after a disastrous fire and is much better known under its final name, the Memphian Theatre. (Courtesy of Malco Theatres, Inc.)

The subdued but handsome front of the Ritz Theatre, opened in 1927 on Poplar Avenue and Evergreen Street, now has a sign and is playing what appears to be *Les Miserables* in 1935. The very plain interior was later ornamented with two rows of elaborate plaster wreaths with the house lights in large seashells at the bottom of each. (Courtesy of MPLIC.)

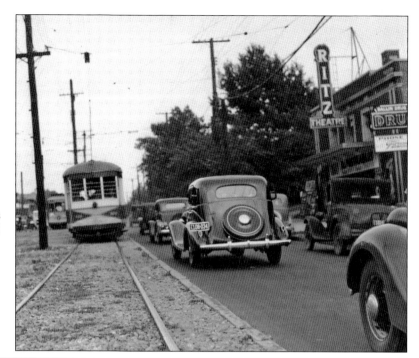

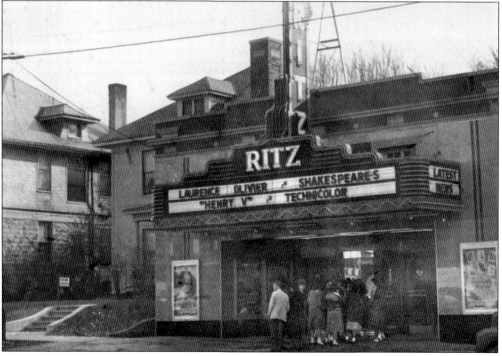

In 1944, beautiful ornamental Vitrolite glass now covers the front and a marquee has been added that would last through the 1970s. During the 1940s, many small theatres used Vitrolite (or its counterpart Structoglas) to give an updated look to the outside. The theatre was known for many years for its foreign and art house films as the Ritz Theatre and later as the Guild Theatre. (Courtesy of MPLIC.)

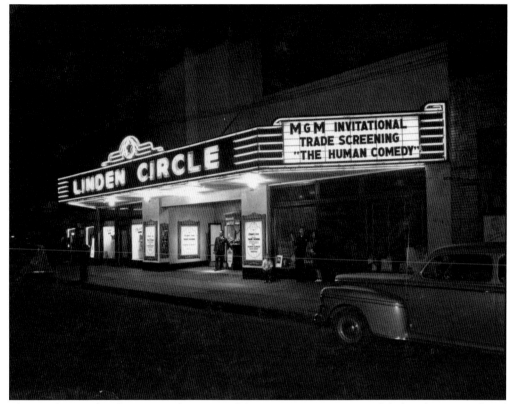

The Linden Circle Theatre, on the street of the same name, was remodeled with a streamlined 1930s modern front and this large marquee. This photograph has some surprises: The trade screening of *The Human Comedy* (1943) is in progress and the manager is unaware of the young couple conversing in the shadows. It was the major neighborhood theatre operated by Malco until the construction of the larger Crosstown Theatre. (Courtesy of MPLIC.)

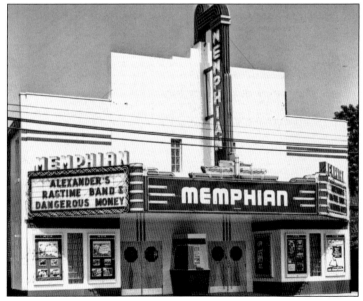

The Memphian Theatre, shown in the late 1940s, has many display elements typical of its era. There are no longer signboards on the front of the marquee, the trapezoid shape provides more room on the side letter boards, and even the chase lights on the sign boards are neon. Colored neon behind the glass blocks between the display cases was a trademark of the Memphian. (Courtesy of API Photographers, Inc.)

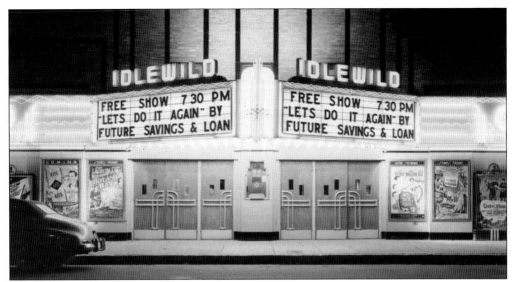

The Idlewild Theatre (1939) was named after its neighborhood. It was built by Chalmers Cullins, Edward Cullins, and Nate Evans. On opening night, gentlemen received cigars and ladies carnations. In the 1960s, it became Front Street Theatre, presenting plays and musicals. This building has had many names and uses and still exists in 2013 as a party facility on Madison Avenue. (Courtesy of Memphis Heritage, Newman Collection.)

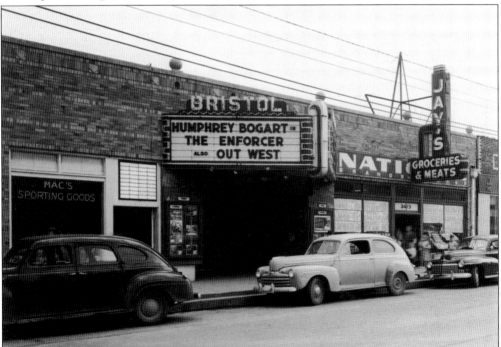

The Bristol Theatre (1929) entrance opened on Summer Avenue near National Street. It, like Loew's State Theatre, had a long, narrow lobby, which went deep into the block before entering the auditorium. Its slender box office was barely big enough for the cashier to sit on a stool. It was run in its last years with a short subject/feature format as a hobby by Mitchell Shapperkotter. (Courtesy of Memphis Heritage, Newman Collection.)

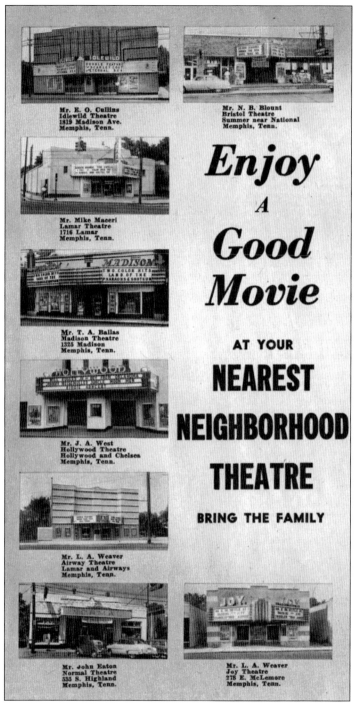

Groups of neighborhood theatres often combined their ads. On Wednesday, October 12, 1955, the *Memphis Press-Scimitar* published its 75th-anniversary edition. This ad, with photographs of eight neighborhood theatres, appears in that issue. The current managers are listed below each image. The only photograph of the Madison Theatre (1926) that has been located is in this ad. It stood near Madison Avenue and Cleveland Street. (Courtesy MPLIC.)

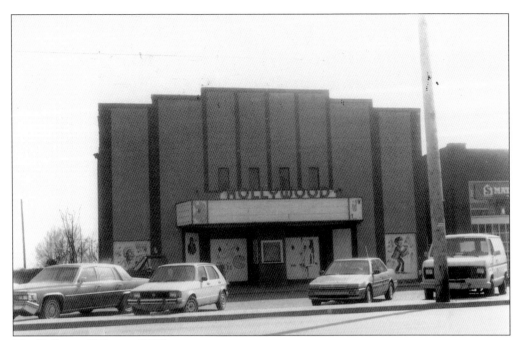

The Hollywood Theatre (1939) stood on Chelsea Avenue near Hollywood Street. It also was named for the surrounding neighborhood. During its history, it was used for films, community events, and lastly as a church. The image, from the 1980s, shows it during one of its closed periods, but the illustrations outside show promise for its future. A few blocks down was the smaller Hyde Park Theatre (1945). Neither has survived. (Courtesy of Bob Ferguson.)

The Lamar Theatre (1927) on Lamar Avenue was advertising Fire Prevention Week when this photograph was taken in October 1949. The building was enlarged in front after it opened, to create lobby space. In its heyday, it hosted talent shows and community events (see chapter opening). Later, one of the most notorious early adult films played there. The film figured in an equally notorious 1976 court case tried in Memphis. (Courtesy of Memphis Fire Department Archives.)

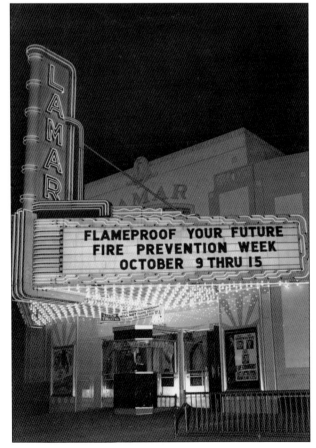

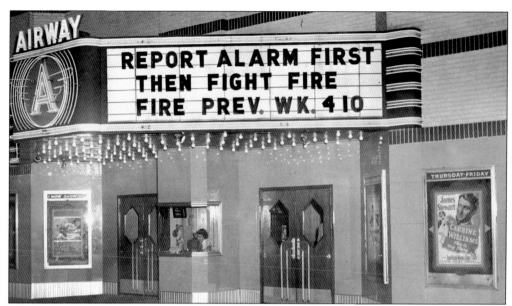

Kemmons Wilson began his long, successful career selling popcorn from a rented machine in front of the Memphian Theatre. He later owned or was a partner in 11 theatres. Though built as the Airway in 1941, the theatre was frequently referred to as the "Airways," which is the name of the street nearby that leads to the airport. Later ads during its adult period used the name Airways. (Courtesy of the Memphis Fire Department Archives.)

Wilson first operated the DeSoto Theatre in Fort Pickering (a former suburb of Memphis) and later built the Airway on Lamar Avenue. It was one of the few neighborhood theatres with a balcony. Kemmons's early staff is shown in this opening-day photograph: his wife, Dorothy, sold tickets; Kemmons took the tickets; and his mother, Ruby "Doll" Wilson, worked the concession stand. (Courtesy of Kemmons Wilson Companies.)

The Newman Theatre opened at this location on Highland Street in 1927. It was succeeded by the Normal Theatre, again named for its neighborhood, in 1931 and was relatively plain with a slender box office like the Bristol Theatre. It played neighborhood fare and attracted students from the nearby West Tennessee State Normal School, now the University of Memphis. (Courtesy of Memphis Heritage, Newman Collection.)

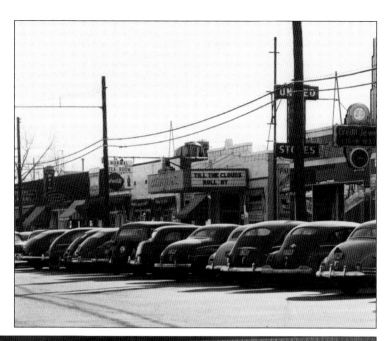

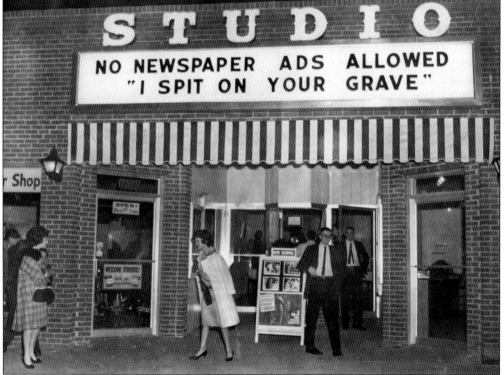

The Normal/Studio Theatre had a completely new front when *I Spit on Your Grave* was playing. The French film was released in 1959. The Studio and Guild Theatres were part of the same art/foreign film circuit in the 1960s. A notable event at the Studio was the Russian *War and Peace* from 1967, which was eight hours long and shown in two installments. (Courtesy of the University of Memphis Library, Special Collections.)

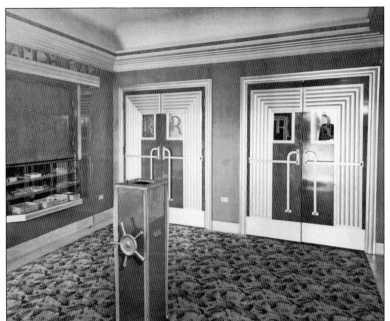

The tiny foyer of the Rosemary Theatre was very stylish with its many mirrored decorations. A larger concession stand was in the oval lobby beyond these doors. The narrow point on its lot posed some challenges for its designer. It was the fanciest of the Cianciolo theatres and the only one with a balcony. (Courtesy of Michael Cianciolo.)

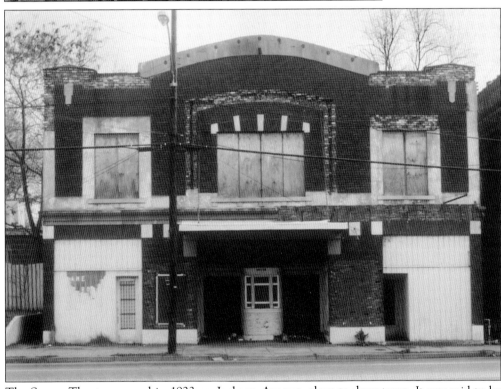

The Suzore Theatre opened in 1923 on Jackson Avenue, close to downtown. It was said to be unroofed early in its career, but it also had side openings on both sides. The corrugated metal shutters were opened for ventilation after sunset, augmented by large fans. It was known later as Suzore's No. 1. A few blocks east stood the Rialto Theatre, owned by Joe Maceri and Paul Zerilla (1926). (Courtesy of www.americanclassicimages.com)

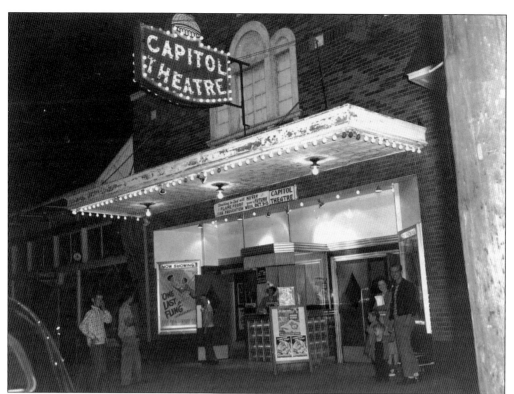

The Capitol Theatre (1930) at 926 East McLemore Avenue had this display in 1949. It served its neighborhood as both employer and entertainment venue. It has the older style of outdoor display—only a sign and a plain canopy. This is one of many images of movie theatres taken during safe driving, antinoise promotions and the like. The banner advertises Fire Prevention Week. (Courtesy of Stax Museum of American Soul Music.)

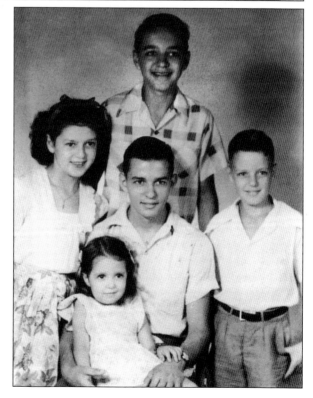

The Boyd family lived directly behind the Capitol Theatre and shared their large house with boarders to augment the family income. George (center) was projectionist and died in World War II. Vance (above, center) was a concessionaire and usher, his sister Edna (left) was a "candy girl." William (right) was a "popcorn boy" and swept out the theatre. Mary Katherine (bottom) dusted the seats. (Courtesy of the Boyd family.)

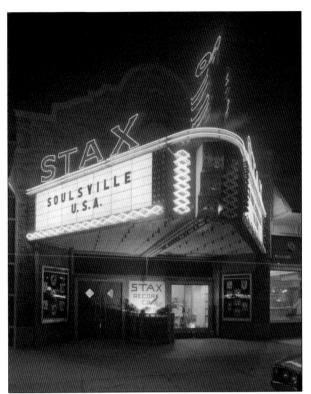

The Capitol Theatre in 1959 became Stax Records, recording many artists such as Isaac Hayes, Rufus and Carla Thomas, The Bar-Kays, Otis Redding, Booker T & the MGs, Little Milton, and Albert King. Several neighborhood theatres had later uses as recording studios. Stax went bankrupt in December 1975, and the building was demolished in 1989. It has been reconstructed as part of the Stax Museum of American Soul Music. (Courtesy of API Photographers, Inc.)

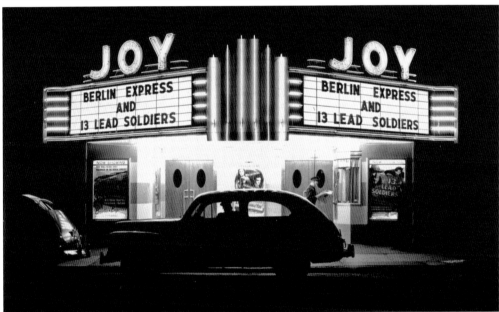

The Joy Theatre opened as the Cameo Theatre on McLemore Avenue in 1928 and was rechristened the Joy in 1934. Its early sign and canopy was eclipsed by this second outdoor display. It was designed by Balton Sign Company, who worked on several neighborhood theatres in the Memphis area. The box office stands to one side of the entrance rather than in the center. (Courtesy of Michael Finger/Balton Sign Company.)

The Park Theatre (1940) was in a freestanding building in its neighborhood. Its prime location was at Park Avenue and Highland Street. Always an independently owned and operated theatre, it showed a wide variety of first-run features. Its owner, Ruben Lester, had an apartment "over the store." It was a popular theatre and is well remembered. (Courtesy of Memphis Heritage, Newman Collection.)

One of the most striking marquee displays was this one, *The Last Picture Show,* which made Memphian Cybill Shepherd a star in 1971. Other memorable films shown here were *Airport, Jaws, Close Encounters of the Third Kind, The Empire Strikes Back,* and *Serpico.* In its last years, it was rentable as a recording studio. (Courtesy of API Photographers, Inc.)

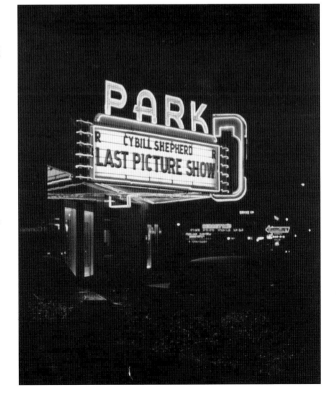

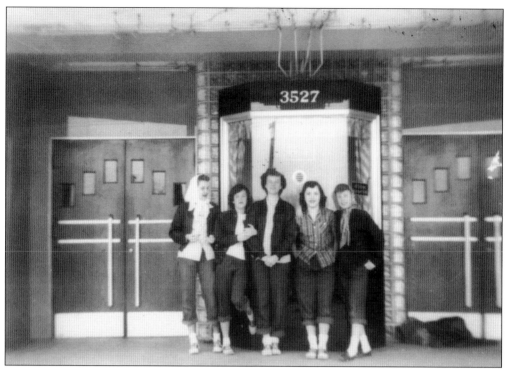

A group of neighborhood girls poses in 1954 in front of the neon-lit box office. Pictured, from left to right, are Peggy Beavers, Mary Ann Kennedy, Barbara Foster, Carolyn Short, and Anne Fletcher. Glass blocks backlit with colored neon were used often to update older theatres and enhance newer ones. The neon surrounding the Park Theatre box office was the most elaborate of the many in this style. (Courtesy of Bob Ferguson.)

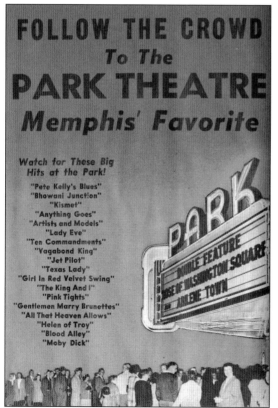

This ad also appears in the same 1955 anniversary edition of the *Press-Scimitar*. It promises a large variety of films, though the real blockbusters would come later. During those years, the small theatre drew patrons from all over town. A story is told that *Earthquake* (in Sensurround) forced the theatre to close for a short while due to the vibrations from the special sound effects. (Courtesy of MPLIC.)

The Rosewood Theatre (1950) was on the corner of Rosewood Avenue and Lauderdale Street. It was built as part of a commercial development on both sides of Lauderdale by Ben Bass. It closed in 1962 and had a long career thereafter as Bennett's Club Rosewood, showcasing live entertainment. The structure later housed a church. (Courtesy of the *Commercial Appeal*.)

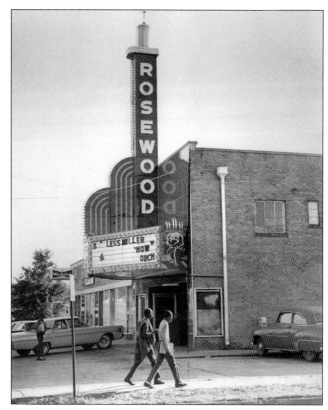

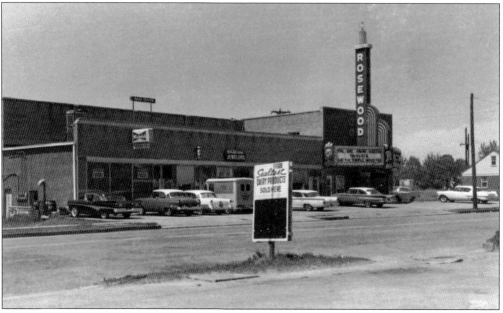

This long perspective shows the theatre auditorium behind its row of storefronts. Many, many theatres had a dogleg in the design, which left the street frontage for commercial use and the auditorium occupying the center of the block. The W.C. Handy theatre had a virtually identical design. (Courtesy of Bob Ferguson.)

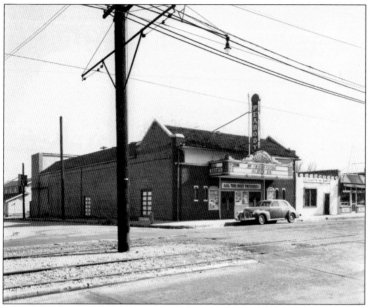

The Peabody (1926) was a Midtown theatre on the corner of Cooper Street and Nelson Avenue. It had an old-style marquee and was unique with its Spanish-tile roof. Playing are *My Friend Flicka* and *Mister Big*, both released in mid-1943. In August that same year, there was an explosion and fire resulting in one death. Stories persist that the building, Memphis Drum Shop in 2013, is haunted. (Courtesy of MPLIC.)

The Peabody was neat but plain and had a cozy box-office foyer with a concession stand that could also serve passersby. The neighborhood now known as Cooper-Young is bordered by East Parkway, Central Avenue, McLean Street, and Southern Avenue. It is divided into four quadrants by the intersection of Cooper Street and Young Avenue. The Peabody served this large neighborhood. (Courtesy of MPLIC.)

Five

I REMEMBER THAT!

From 1928 until 1956, Lloyd Tilgham Binford was chairman of the Memphis Board of Censors. Born in Duck Hill, Mississippi, Binford enjoyed free rein to edit films—known as having been "Binfordized" by Hollywood—or ban them outright. Many of his bans in later years resulted in Memphians crossing the river to see films at theatres in West Memphis, Arkansas. (Courtesy of the University of Memphis Library, Special Collections.)

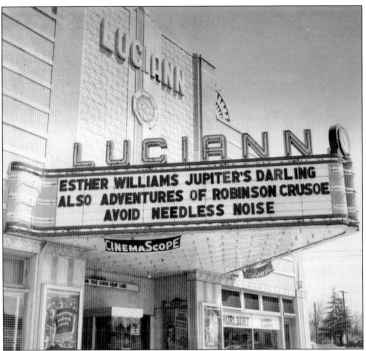

The elder Michael Cianciolo built the Luciann Theatre in 1940 on Summer Avenue near Hollywood Street and named it for two of his daughters, Lucy and Ann. It, by far, had the most beautiful facade of any theatre except the Warner Theatre downtown. All of the ornamentation was cast concrete. It served a very large neighborhood. This photograph is from 1955. (Courtesy of Bob Ferguson/ Memphis Police Department Archives.)

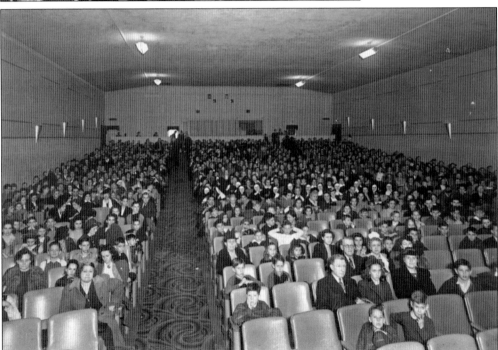

The audiences at the neighborhood theatres were loyal for many years, walking sometimes from their homes to the movies. Some managers could find their regular patrons in the same seats, time after time. In the center of this image of the Luciann Theatre is a group of Franciscan Sisters from St. Joseph Hospital, easily identified by the oval fronts of the habits around their faces. (Courtesy of Michael Cianciolo.)

The Luciann interior was pleasantly decorated but not overly fancy. As neighborhood theatres began to lose popularity, it became a nightclub, a bowling alley, a dance club named The Party, and finally an adult theatre. Its many uses preserved the exterior with very little change, and it is still striking in 2013. (Courtesy of Michael Cianciolo.)

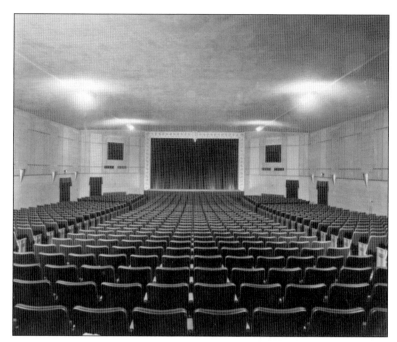

Augustine "Gus" Cianciolo managed his father Michael's theatres and continued the family tradition in grand style. The Cianciolo theatres catered to family audiences but Gus was not afraid to show films with social commentary. *A Patch of Blue* (1965), which stars Sidney Poitier opposite Elizabeth Hartman (a story of love between people of two races), caused much controversy but completed its scheduled run. (Courtesy of Michael Cianciolo.)

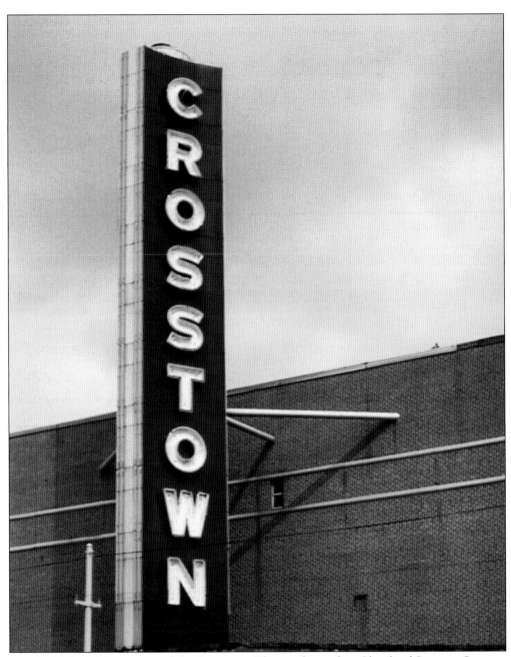

In 1951, Malco Theatres opened the Crosstown Theatre, located on Cleveland Street at Overton Park Avenue in Midtown Memphis. The name Crosstown comes from the old north-south streetcar line going down Watkins and Cleveland Streets, then further south, and finally ending at Riverside Park. The vertical sign was 72 feet high and began 20 feet above the ground. The letters were filled with white neon, edged in green neon, and backlit in red neon. The enormous vertical and marquee were supported by two columns that created a large space underneath and also had a driveway where patrons could be dropped off. There was room for large-scale promotions, such as the giant rat for *Willard* in 1971, and special marquee letters in the typestyle of movie titles. (Courtesy of www.americanclassicimages.com.)

The Crosstown cost $400,000 to build and had a seating capacity of 1,400. It was designed by the architectural firm of Brueggeman, Swaim & Allen and was the largest neighborhood theatre in Memphis. The front of the Crosstown, according to *Boxoffice Magazine* for April 5, 1952, "employs approximately one mile of neon tubing in the installation, requiring 40 circuits and 143 transformers." (Courtesy of Bob Ferguson/Memphis Police Department Archives.)

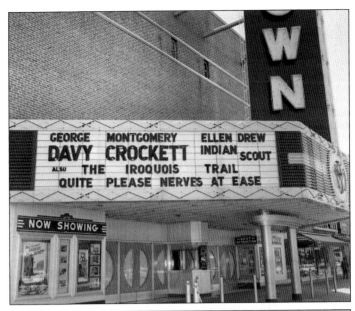

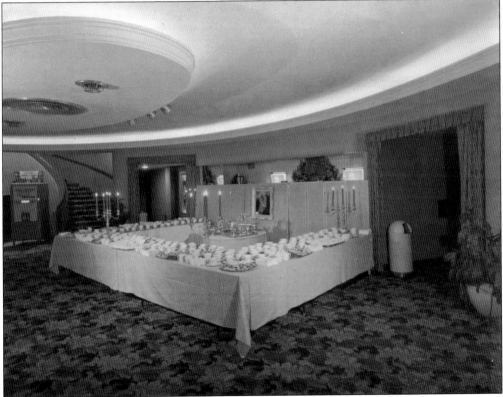

The beautiful oval lobby of the Crosstown Theatre is set up for a reception in 1965, with a screen covering the concession stand. The auditorium interior was cove-lit and highlighted by a deep green contour curtain. The building was purchased by the Jehovah's Witnesses in 1976 and for a long while the huge vertical still stood. There have been very few changes in the lobby, and the twin curving staircases are still beautiful in 2013. (Courtesy of Malco Theatres, Inc.)

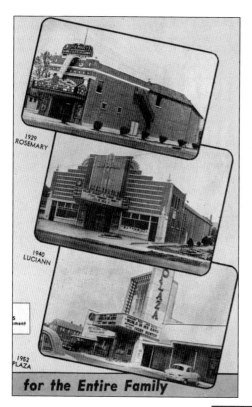

The Cianciolo theatres are shown together here as part of an ad in 1955 announcing the construction of a new theatre in Whitehaven Plaza. That theatre was never completed, but a Whitehaven Cinema was constructed in 1966 by General Cinema and was twinned in 1973. Instead of a new theatre in Whitehaven, the southernmost suburb, a theatre was opened in Frayser, the northernmost suburb. (Courtesy of MPLIC.)

In 1952, Augustine Cianciolo took a large risk and opened the Plaza Theatre in the newly constructed Poplar Plaza Shopping Center. Designed by Everett Woods Sr., its massive front window and vertical letters drew attention for the entire shopping center as well as for the theatre itself. Poplar Plaza was Memphis's first large shopping center, located at Poplar Avenue and Highland Street. (Courtesy of www.americanclassicimages.com.)

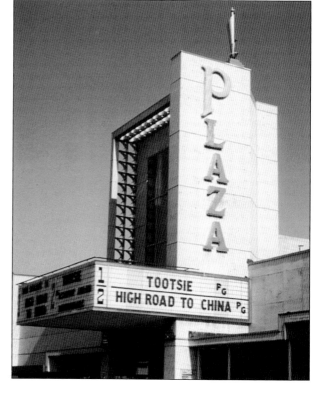

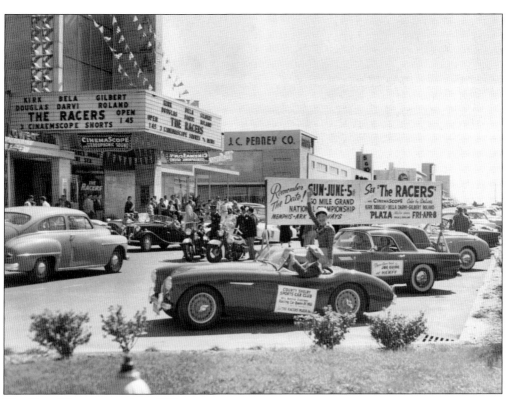

The Plaza Theatre opening of *The Racers* (1955) was heavily promoted. The Plaza had curves in every room. The lobby was curved, the concession was curved, and both lounges had smoking rooms that curved away from the lobby and had no outer doors. Its large, curved auditorium contained a small stage and both an upstairs party room and a "cry room" behind glass. (Courtesy of Michael Cianciolo.)

The Plaza lease was sold to General Cinema Theatres in 1961 and the theatre later twinned. It closed in 1987 and reopened as a Bookstar, retaining the original decor with added neon highlights. The curling spire was removed and is displayed at the University of Memphis. After Bookstar closed, the interior was gutted for two businesses. The great window and canopy still remain in 2013. (Courtesy of the author.)

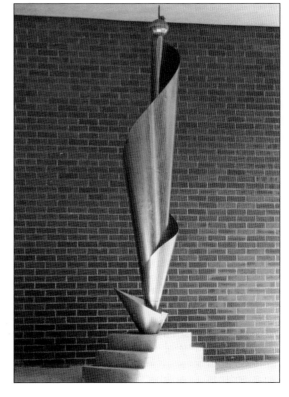

The Plaza Theatre's most dramatic evening occurred when Elvis Presley came for a movie. An usher saw him before he could be spirited up to the party room, shouted "Elvis is here!" and pandemonium erupted. The crowd was frantic to catch a glimpse. It is said that the Plaza's manager was the first to utter "Elvis has left the building" to restore order. This view is from 1981. (Courtesy of www.americanclassicimages.com.)

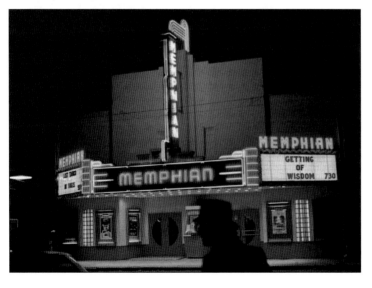

Elvis rented the Memphian Theatre many times for late-night films for himself, family, and friends. A seat that he used is marked with a plaque, and he was said to have been a big tipper to the staff who worked these long evenings. The latest films traveled from other theatres to the Memphian for these gatherings. This photograph was taken in 1980. (Courtesy of David Cotton and Brig Klyce.)

Elvis poses for this photograph in 1957 with his former boss, Arthur Groom, from Loew's State Theatre. Groom fired Elvis after an altercation with another usher but later reinstated him. Groom was still working at the State when *Love Me Tender* opened in 1956. Elvis had a private showing. Many of Elvis's other films played the State. (Courtesy of Robert Dye, Elvis Presley Enterprises and Micki Groom Creamer.)

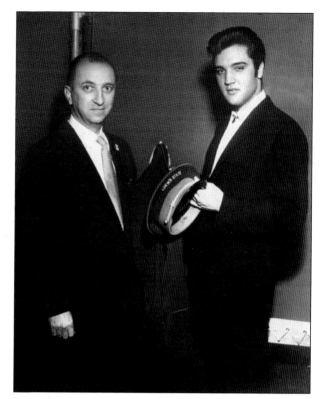

The old Lincoln Theatre, as Suzore's No. 2, was Elvis's neighborhood theatre when he lived in the Lauderdale Courts nearby. The L from the Lincoln era is still visible behind the vertical sign. He is said to have been hiding out in Suzore's No. 2 the night "That's All Right" first played on the radio. His family fetched him home for his first radio interview. (Courtesy of the Shelby County Archives.)

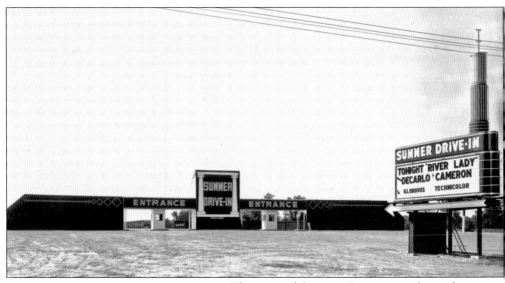

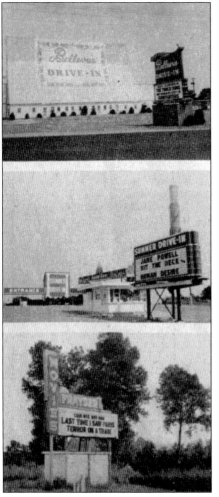

The original Summer Drive-In was located on Summer Avenue near White Station Road, and opened in 1948. It was owned by Kemmons Wilson and Lou Weaver, held 670 cars (one of the largest in the country at the time), and had this beautiful sign and entrance provided by Balton Sign Company. Wilson's first Holiday Inn was built not far west of the drive-in, on Summer Avenue in 1952. (Courtesy of Michael Finger/Balton Sign Company.)

These images appear in an ad for Malco Theatres in the 75th-anniversary edition of the *Press-Scimitar* in 1955. It shows the Bellevue (1951) and Frayser (1951) drive-ins. Both held 600 cars. Malco also operated the Summer Drive-In. The Bellevue's display was the handsomest, with a pink neon picture frame covering most of the back of the screen tower, facing Bellevue Boulevard (now called Elvis Presley Boulevard). (Courtesy of MPLIC.)

The Sky-Vue Drive-In (1949) was located on Park Avenue in the heart of Orange Mound, a "colored" neighborhood, though the drive-in was for white patrons. The "colored" drive-in was called the Lincoln and was in a different neighborhood. These films played the Sky-Vue in 1958. (Courtesy of the Memphis Police Department Archives.)

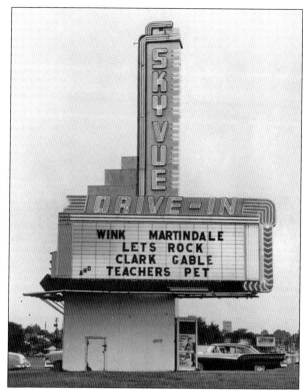

The Sky-Vue had space for 750 cars but included 700 outdoor seats, a playground, and two concession stands. Streets with houses and apartments ran behind the property and it was no trouble to watch the movie from outside. Despite all these conveniences, it closed in 1970. (Courtesy of Robert Dye.)

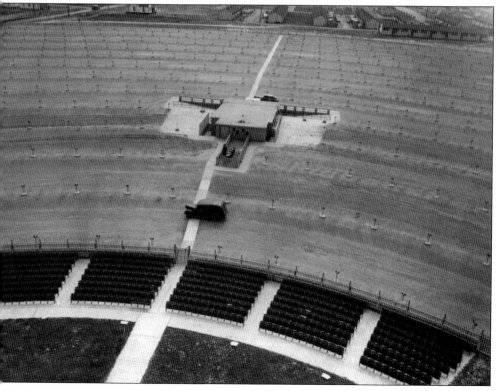

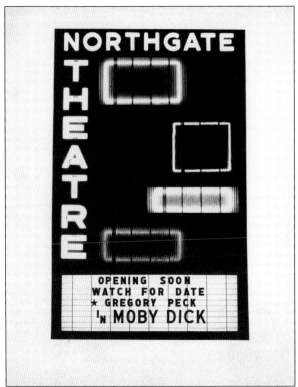

The Northgate Theatre opened in Northgate Shopping Center in 1956. It is located in Frayser, the northernmost suburb of Memphis. The Northgate incorporated most of the amenities created in the other large neighborhood theatres. Its screen went wall to wall, nearly 50 feet; it had a cry room like the Plaza and a shaded drop-off area like the Crosstown. It provided wheelchair seating and had upper-level stadium seating, which was far ahead of its time. The Fifties-modern sign stood atop the shopping center, but the entrance to the theatre faced the back of the property and did not attract much walk-in traffic. It closed in the 1970s. It has had various uses since. (Both, courtesy of Michael Cianciolo.)

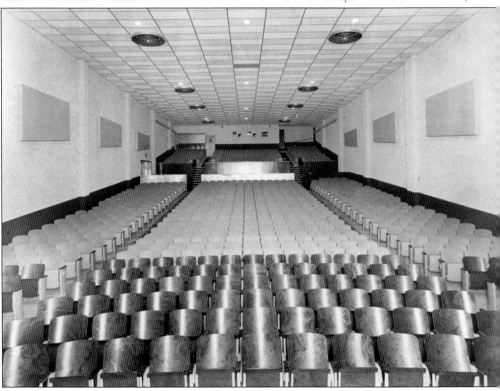

Six

DIVIDE AND CONQUER

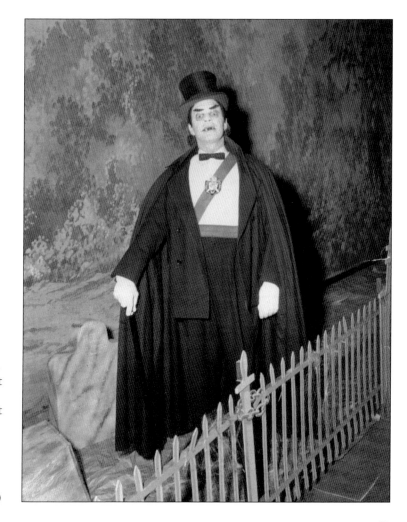

Watson Davis was the advertising director for Malco Theatres. He staged spectacular promotions for horror movies and, from 1962 to 1972, appeared as Sivad (Davis spelled backwards), "your monster of ceremonies," on *Fantastic Features*. This weekly spooky movie gave an entire generation of children nightmares every Saturday night on WHBQ-TV. He appears here in front of an old Orpheum Theatre vaudeville backdrop. (Courtesy of the University of Memphis Library, Special Collections.)

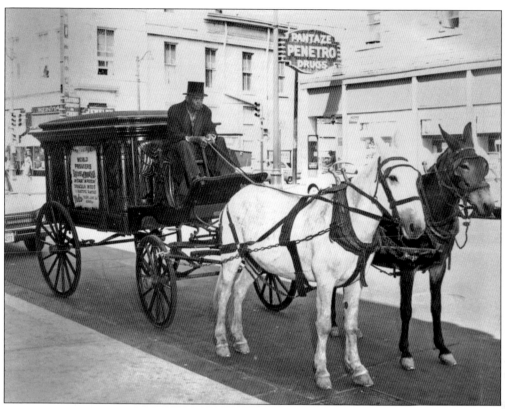

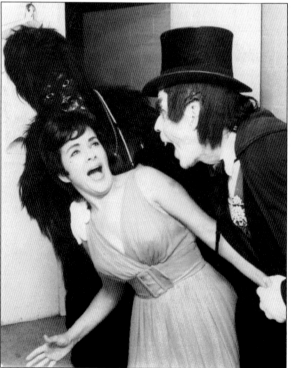

This antique hearse, with horse and mule pulling together, appeared on Main Street in front of the Malco Theatre for the premiere of *The Brides of Dracula* (1960), with Peter Cushing. The same hearse was used by Watson "Sivad" Davis in the opening of *Fantastic Features*. Davis engineered many of his promotions, even building oversize monsters to decorate the marquee and stage himself. (Courtesy of the Memphis Pink Palace Museum.)

Sivad became a local celebrity and attracted 30,000 people to a personal appearance at the Mid-South Fair. Managers and office personnel dressed as an entire team of monsters for horror movie openings. There were a number of these huge stage events as well as elaborate displays in the lobby. The last "Ghoul-arama" with Sivad in attendance was in 1971. (Courtesy of the Memphis Pink Palace Museum.)

Richard Lightman and his brother, M.A. Lightman Jr., ran Malco Theatres in the decades after M.A. Sr.'s death. After a meeting with the NAACP in 1962, Dick Lightman began a gradual integration of the Malco on Main and Beale Streets, the first theatre in Memphis to formally integrate. It was followed by the rest of the Malco theatres, with only one incident, and then all of the other Memphis theatres. (Courtesy of the University of Memphis Library, Special Collections.)

The Malco hosted a one-night showing of *King: A Filmed Record . . . Montgomery To Memphis*, a documentary about Dr. Martin Luther King Jr., on March 24, 1970, one of a select number of theatres to do so. A revival of intermission concerts on the Mighty Wurlitzer organ was also beginning. Bill Oberg restored much of the organ and continued the tradition of Art Hays and Milton Slosser. (Courtesy of the *Commercial Appeal*.)

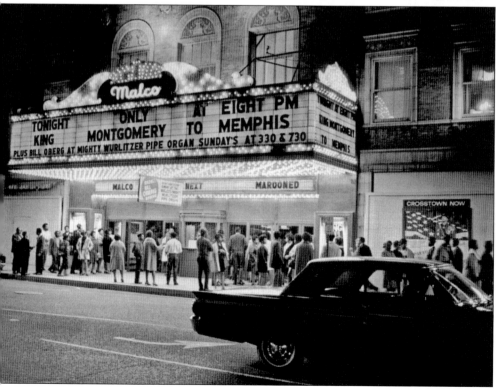

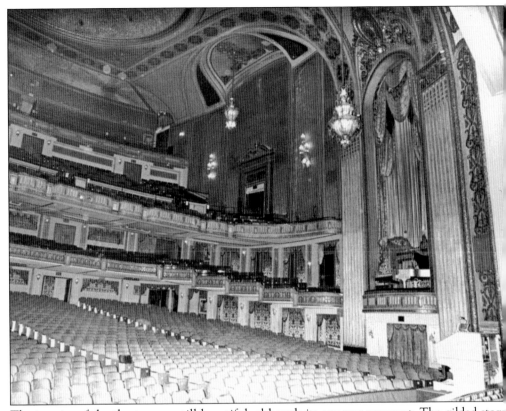

The interior of the theatre was still beautiful, although its age was apparent. The gilded stage piano and two of the organ's percussions were mounted in the south loge at this time. The piano was retired and the percussions were returned to the organ chambers after the theatre closed. By this time, all the levels were permanently connected to one another and the side entrance closed. (Photograph by Gary Walpole, courtesy of the author.)

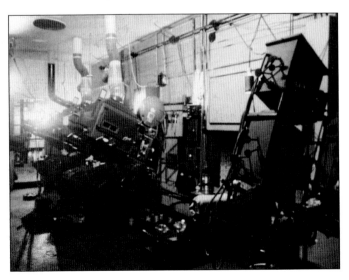

The projection booth contained a room full of equipment—some used daily, some only occasionally. On the right is a Brenograph effects projector from 1928, which could use a variety of lenses and two lamps for special effects. Two spotlights remained from the same era. The later movie projectors had a sharp tilt and special aperture plates due to the steep angle down to the screen. (Courtesy of the author.)

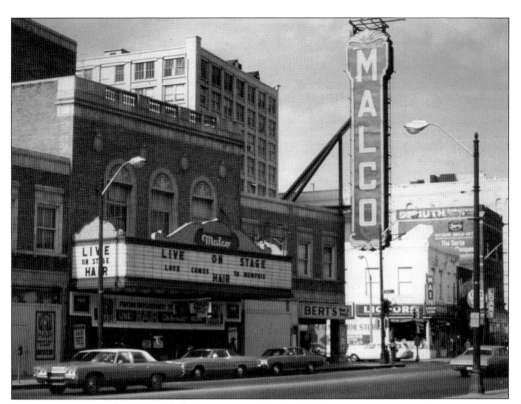

In 1972, two musicals reopened the stage of the Malco. *Hair* played in January and a nostalgia revival of *No, No, Nanette*, with Don Ameche, Evelyn Keyes, Swen Swenson, Lainie Nelson, and Ann B. Davis, played in November. These shows proved that Memphis patrons could support another live theatre downtown. It paved the way for the building's eventual new career. (Courtesy of Malco Theatres, Inc.)

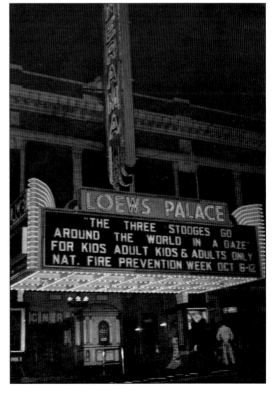

In July 1961, *This Is Cinerama* opened at Loew's Palace Theatre. A special booth to house the three synchronized projectors was built on the main floor and a great curved screen installed. In 1963, *How The West Was Won* was the last Cinerama feature to be shown at the Palace. It closed just before this photograph was taken. The base of the vertical, with "Cinerama" in neon, is visible and the Cinerama logo can be seen behind the box office. (Courtesy of Memphis Fire Department Archives.)

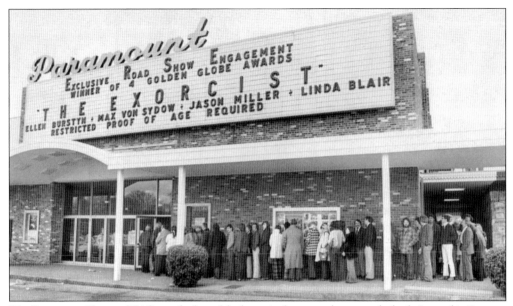

The Paramount Theatre (1964) was the last of the large single-screen theatres to be built. It stood in Eastgate Shopping Center on White Station Road. It seated 858 and had a gold-draped, curved auditorium that was later twinned. It is best remembered for the high-tech, reserved-seat run of *The Sound of Music*, which ran for 79 weeks in 1965–1966. (Courtesy of the University of Memphis Library, Special Collections.)

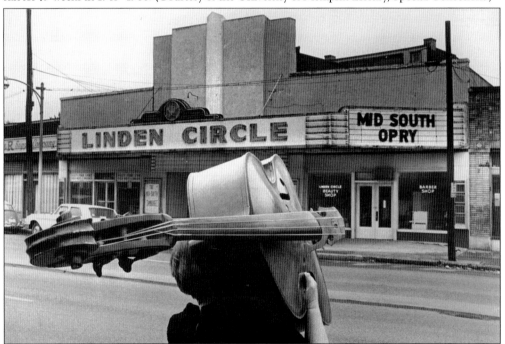

The Linden Circle Theatre had a different career in 1966 when it became a showcase for live acts, mostly country and western, and the Mid-South Jamboree on Friday nights was very popular. Dolly Parton, Porter Wagoner, String Bean, Grandpa Jones, and Eddie Bond all performed there. The building still stands in 2013 on Linden Circle, a curved section connecting Somerville Street to Linden Avenue. (Courtesy of the *Commercial Appeal*.)

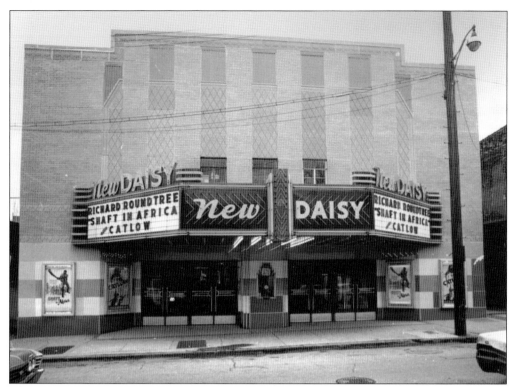

The New Daisy Theatre was playing this double bill in the early 1970s during the height of the blaxploitation era. After the Malco Theatre was sold in 1976, it was the last vintage theatre to operate on Beale Street. It closed in 1978, but escaped the urban renewal that took the Palace Theatre and most of the rest of its block. (Courtesy of the Shelby County Archives.)

The Old Daisy Theatre, across the street, had already been closed since 1956, its seats removed and its famous facade beginning to crumble. It still appeared in works of art and photographs. Also, the fixtures from which the huge, white globe lights hung (from its nickelodeon days) are still visible. (Courtesy of the Shelby County Archives.)

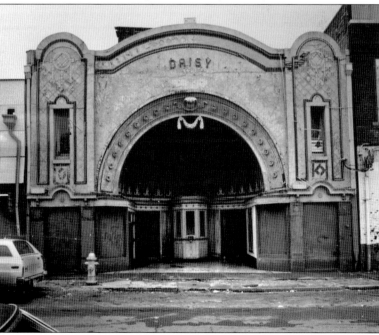

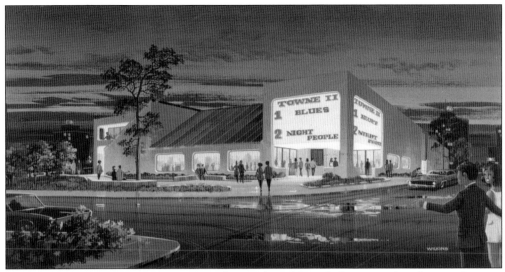

In July 1975, the Towne II Cinema opened at Beale and Fourth Streets with only one of its two planned auditoriums and shortly thereafter became the Muhammad Ali Towne II Cinema. It was the first cinema on Beale Street built by an African American, George Miller, who still owns the property in 2013. Several clubs have since operated in the building. (Courtesy of the University of Memphis Library, Special Collections.)

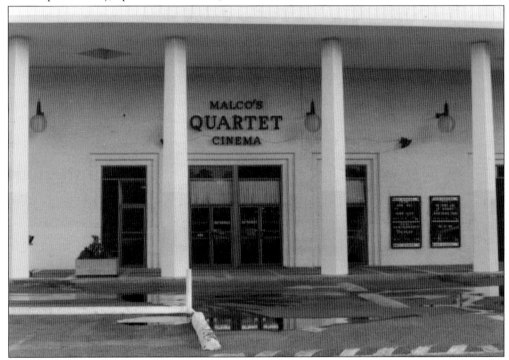

Malco's Quartet Cinema, the first in the region, was opened in 1971 at the corner of Poplar Avenue and Highland Street. It was set far back from the street with very little signage, but the novelty of the small four-plex and its choice of four first-run pictures attracted patrons for many years, particularly from the University of Memphis nearby. A small collage of images of movie stars decorated the lobby. (Courtesy of MPLIC.)

The minimalist style of the 1970s and restrictions imposed by the shopping center made the Quartet's sign the exact opposite of the marquees of years past. It was later known as the Highland Quartet, and the later sign was smaller than the original. Numerous four-plex cinemas owned by different companies came and went. The original Quartet (the first to be titled "Cinema") closed in 2005. (Courtesy of Malco Theatres, Inc.)

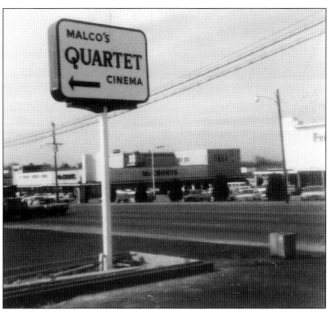

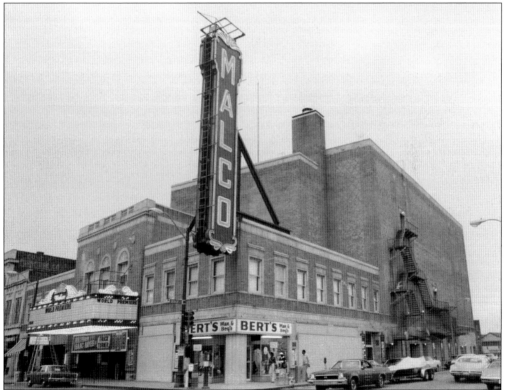

The Ridgeway Four Cinema opened in 1977 and was built to also house the home offices of Malco Theatres. "Big Malco" on Main and Beale Streets was sold to the Memphis Development Foundation and rechristened the Orpheum Theatre. It was to be part of the Beale Street Landing commercial development nearer the river but itself became the first successful rejuvenation on Beale. (Photograph by Stan Hightower, courtesy of the author.)

The *Hollywood Stars* mural has always been the focal point of the Ridgeway Lobby. The Ridgeway Cinema Grill has been entirely remodeled in 2013, its lobby updated with video displays and its concession serving sandwiches and wine. A bistro atmosphere has been created; it plays art, foreign, and unique films, all first-run; and it programs for an audience that likes the unusual. (Courtesy of Malco Theatres, Inc.)

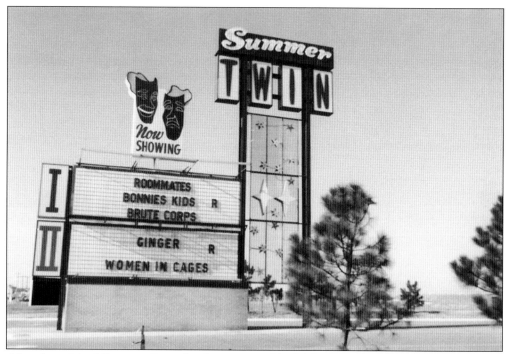

After the original Summer Drive-In, then operated by Malco, was closed for redevelopment in 1966, it was replaced by the Summer Twin in the same year. The Summer Twin was further out Summer Avenue, but not much further. The huge property is concealed by undeveloped areas and a shopping center, with only the entrance drive and marquee visible. (Courtesy of Malco Theatres, Inc.)

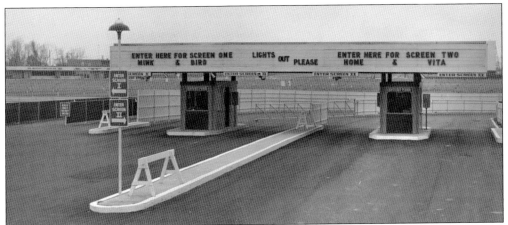

The Summer was entirely 1960s modern. The concession building contained a small auditorium with regular theatre seats, an enormous concession stand and a patio, the restrooms, support areas, and projection booth. This entry to the Summer Twin is basically unchanged, and it has faithful patrons, who are now bringing their grandchildren out for their own drive-in experiences. (Courtesy of Malco Theatres, Inc.)

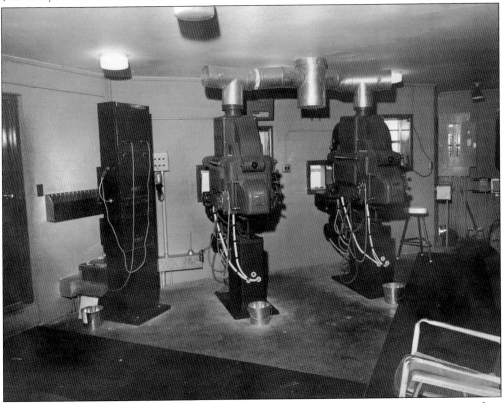

Inside the projection booth were twin projectors; it was later expanded to four projectors and an updated projection system. The projectionist frequently made the intermission announcements and his voice was as familiar as the smell of the popcorn. The intermission advertisements were usually animated and clever (and long) so everyone could get served before the next feature. (Courtesy of Malco Theatres, Inc.)

Marion Post Wolcott took this photograph of cotton "snakes" (waste cotton from the sampling floors) on Union Avenue in 1939. These would normally be seen on Front Street, but they are stacked just outside the Cotton Exchange at Union Avenue and Front. The first marquee of Loew's Palace is in the center, advertising *Disputed Passage*, starring Dorothy Lamour. (Courtesy of the Library of Congress, Prints & Photographs Division, FSA/OWI Collection.)

The Carrolton Theatre is shown here during a parade around 1913. It was one of the short-lived storefront theatres, but the presence of "colored" spectators may mean that it served that community. It was on North Main Street at Washington Avenue, not far from where the Lincoln was built. (Courtesy of Bill Adelman/ Fire Department Archives.)

Seven

SELECTED SHORTS AND SURVIVORS, 2013

This nostalgic photograph of Buddy Bruckner looking at the Rosewood Theatre was taken by Bob Ferguson around 1959, the year *Warlock* was released. This is not a horror film but a Western with Richard Widmark, Henry Fonda, Anthony Quinn, and Dorothy Malone, and a complicated plot. The other two films are possibly *The Snow Queen* (Russian animated film, 1957) and *The Purple Monster Strikes* (1945). (Courtesy of Bob Ferguson.)

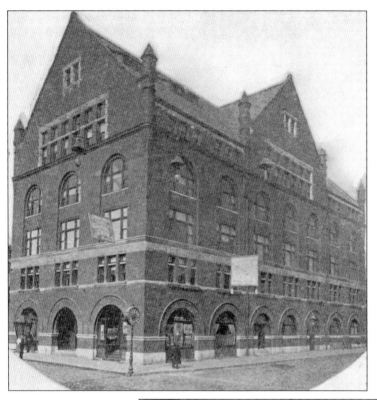

The first Lyceum Theatre was on the lower story of the Memphis Athletic Association when it was built in 1890 at Third and Union Avenue. Farce, comedy, opera, and "legitimate" programs were advertised. Notice the small round street sign. It reads "Lyceum Theatre." The Princess Theatre had a similar sign. This building burned in 1893 and was replaced by the New Lyceum Theatre at Second Street and Jefferson Avenue. (Courtesy of the *Commercial Appeal*.)

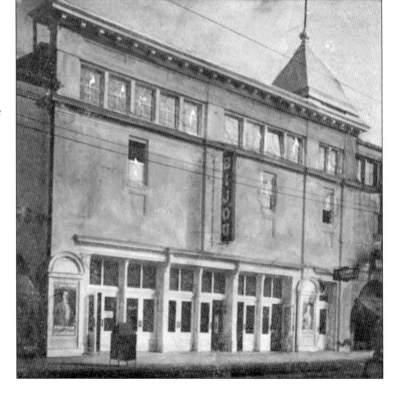

The first Bijou Theatre opened as the Auditorium Theatre in 1893, and was a remodeled carriage/streetcar barn. It became the Bijou in 1903. Primarily a live theatre, its contribution to cinema history was a demonstration of the Cinematograph in 1896. It burned in 1911 and was not rebuilt. The Chisca Hotel stands on its site at Main Street and Linden Avenue. (Courtesy of MPLIC.)

The second Lyceum Theatre is brilliantly illuminated at night during the 1920 run of *The Heart of a Child* starring Alla Nazimova. The enormous corner electric sign predates the marquee (the "Loew's" has been inserted) and was a landmark until 1932. Its age caused the city to condemn and remove the sign. (Courtesy of the Theatre Historical Society of America, Loew's Collection.)

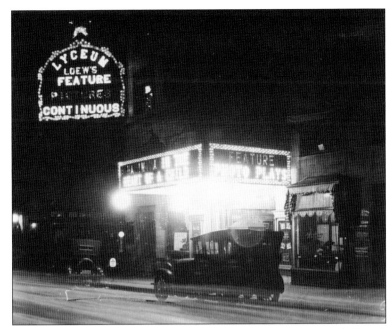

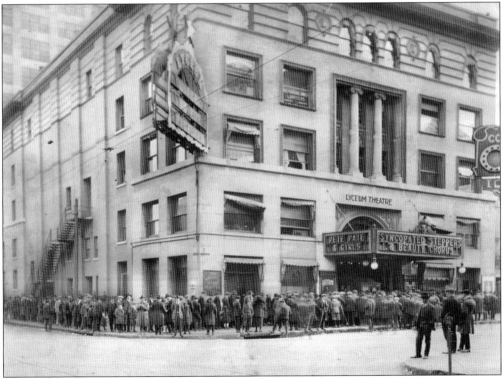

In its later years, girlie shows and burlesque were a big attraction at the Lyceum. Pete Pate advertised for chorines at the theatre as early as 1921. Many types of entertainment were tried at the former showplace, lastly boxing and wrestling. It closed with a nostalgic retrospective article in the *Press-Scimitar* and was demolished in 1935. (Courtesy of Robert Dye/University of Memphis Library, Special Collections.)

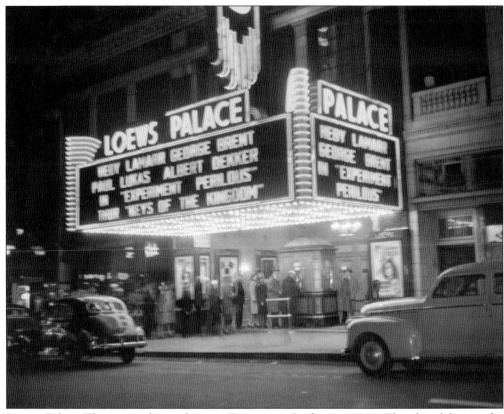

Loew's Palace Theatre is playing host to *Experiment Perilous* in 1944. The chandelier in the beautiful box office foyer is visible and the roof of the box office itself was stained glass, lit from beneath. Several Navy men can be seen in line. (Courtesy of the University of Memphis Library, Special Collections.)

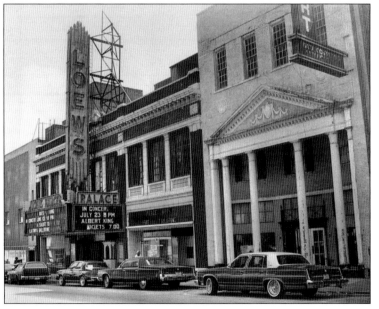

The Palace again became a stage theatre in 1977 when owned by Bountiful Blessings Deliverance Church, but came down in 1985. The classical front beside the Palace was the entrance to a Britling Cafeteria. Gladys Presley, Elvis's mother, worked for a time at a downtown Britling Cafeteria in Memphis, perhaps this location. (Courtesy of the *Commercial Appeal*.)

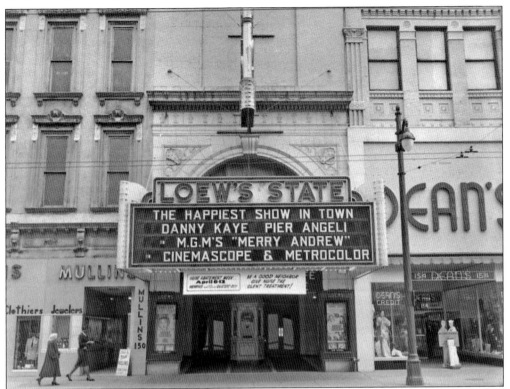

Loew's State Theatre is still beautiful in 1958; its marquee was a twin to Loew's Palace. The antinoise campaign on the banner helped keep Memphis known as the cleanest, quietest, and safest city in the country in the 1950s. The outer foyers are also very close to being identical with the Adam decorations on the box office and the Loew's name over the display boxes. (Courtesy of the Memphis Police Department Archives.)

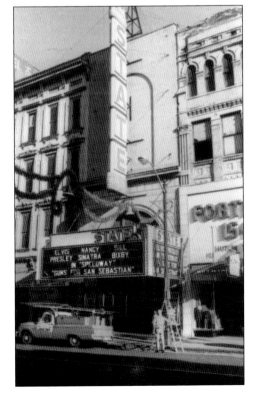

Loew's State Theatre was owned by Loew's Inc. until 1964, when it was sold to Gulf States Theatres. Elvis movies are still playing at the State in this photograph from 1968. It disappeared in 1970, a victim of urban renewal. Peabody Place now cuts through the block approximately where the entry was, and its location is still pointed out on Elvis tours. (Courtesy of the Shelby County Archives.)

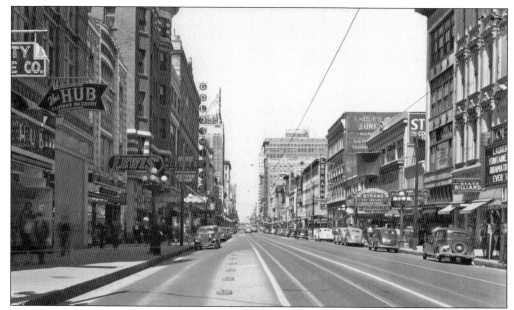

In 1940, the Majestic/Strand Theatre had its second marquee, now only as wide as the entrance, and is playing *The Invisible Man Returns*, with Cedric Hardwicke and Vincent Price. The Majestic Theatre on the left has been remodeled into Lewis' (later Julius Lewis) clothing store. Curiously, the left (west) side of Main Street looks very much the same in 2013 whereas the right (east) side in this block has completely disappeared. (Courtesy of MPLIC.)

In 1968, the Strand Theatre had turned to soft-core adult fare and had its most familiar marquee. *Office Love-In* was the main feature. Lucky Bang Bang was the stage name of actor Lucky Kargo, who played in a number of forgettable soft-core films of this era. The Strand Theatre, too, was a victim of urban renewal and was torn down after the State. (Courtesy of the Shelby County Archives.)

The Future Farmers of America, 7,000 strong, parade down Main Street during the 1939 Mid-South Fair, successor to the Tri-State Fair. The Princess Theatre still has much of its facade intact, including the canopy, which had to be notched to fit around two streetlights. The film is *Wall Street Cowboy*, with Roy Rogers and Gabby Hayes. (Courtesy of the Shelby County Archives.)

In 1968, the Princess was a shadow of its former self—the bad odor would never go away. However the street-side concession remained busy. The film *Fever Heat* (1968) stars Nick Adams and the film *The Ride to Hangman's Tree* (1967) stars Jack Lord and James Farentino. No one noticed the remaining interior plasterwork and fanlight until it was demolished a few years later. (Courtesy of the Shelby County Archives.)

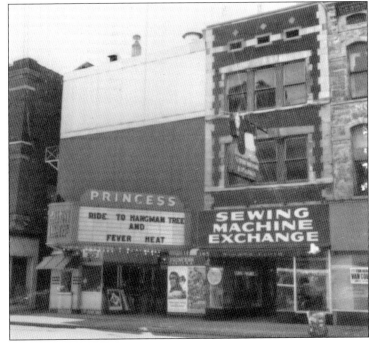

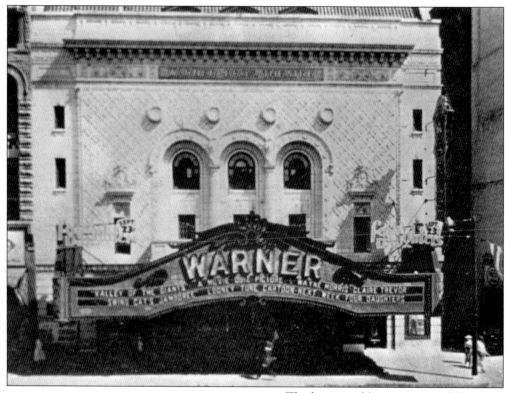

The long, sparkling marquee of the Warner Theatre has been used to full advantage. *Valley of the Giants* (1938) is the feature; there is a Movie Quiz Picture, Swing Cats Jamboree, a Looney Tunes cartoon, and the next attraction, *Four Daughters*. *Four Daughters* (1938) was evidently much anticipated; it stars Claude Rains and John Garfield, and merited the two large title displays on either end. (Courtesy MPLIC.)

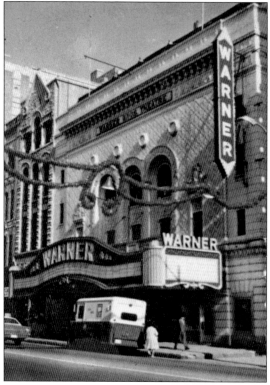

At Christmastime in 1968, the Warner marquee is empty and the theatre awaits demolition. It was the first movie palace to go, replaced by an office tower attached to the classic bank building behind. Its demise was marked in the newspapers, but it was mourned very little at the time. (Courtesy of the author.)

Muvico's Peabody Place 22 Cinema opened with a gala to benefit St. Jude Children's Research Hospital on June 9, 2001. The entrance shows the unusual placement of the complex with the main box office on the atrium floor, the entrance on the second level (to allow an exit beneath), and the cinema's auditoriums on a third level, behind the windows. (Courtesy of Richard Keenan and Muvico Theatres.)

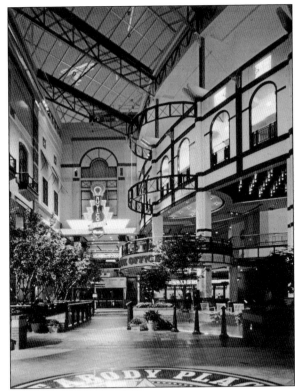

In April 1997, Belz Enterprises, owners of The Peabody Hotel, announced that Muvico Theatres would build a "state-of-the-art movie megaplex" in its new Peabody Place Urban Retail and Entertainment Center. Peabody Place promised retail stores, specialty shops, theme restaurants, and movies. Upon entering the cinema, which contained a party and playroom on the entry level, patrons faced an escalator that traveled to the spacious, "railway terminal" lobby. (Courtesy of Dale Berryhill.)

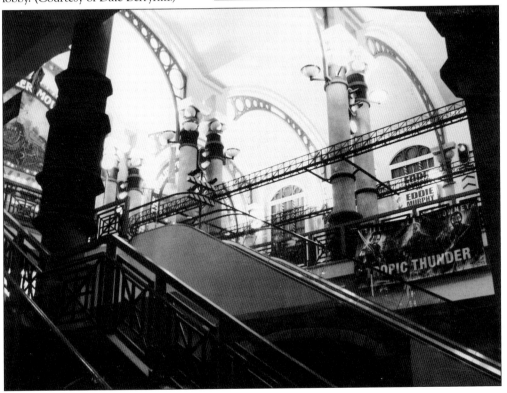

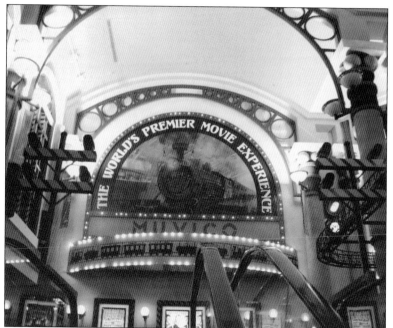

At the top of the escalator was this mural of a steam locomotive. The auditoriums had similar murals on the side walls, the most current equipment, and stadium seating. The largest screen, 80 feet in width, was in a six-story auditorium, entered to the left of this mural. It showed large-format films, both concert and first-run. (Courtesy of Dale Berryhill.)

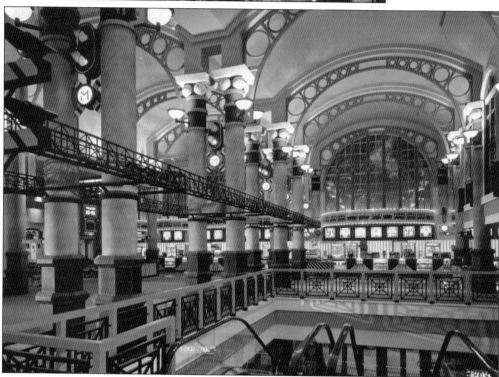

The lobby was grand in every sense of the word, with a concession stand extending the entire width of the south wall. Filled with props and displays, it was the most spectacular theatre or cinema lobby Memphis had ever seen. Two long hallways on either end of the concession stand took patrons far from the lobby. The cinema literally surrounded the atrium below. (Courtesy of Richard Keenan and Muvico Theatres.)

One of the model trains that constantly traveled the elevated tracks can be seen here. The Indie Memphis Film Festival took place at "The Muvico" from 2002 to 2007. The gay/lesbian-themed Outflix Film Festival was held there in 2006 and 2007. The best-remembered event was the Hollywood-style premiere of Memphian Craig Brewer's *Hustle and Flow* (2005). (Courtesy of Richard Keenan and Muvico Theatres.)

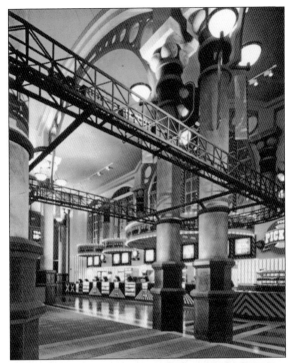

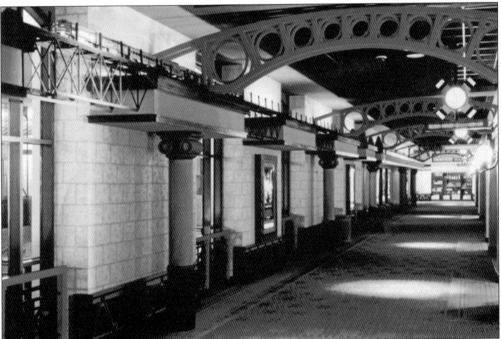

Another model train traveled through these corridors. Problems beset the theatre despite all efforts: Young crowds caused disturbances that discouraged older patrons. A nearby arena used up all the surrounding parking during evening events, which adversely affected prime-time feature showings. All these resulted in the closing of the theatre in 2008. It was dismantled to become luxury suites for the adjacent Peabody Hotel. (Courtesy of Richard Keenan and Muvico Theatres.)

Willie Mitchell's Royal Studios is located in the former Royal Theatre at 1320 South Lauderdale. The theatre closed in 1955 and in 1956 was converted to a recording studio. Among some of those who have recorded at Royal Studios were the Memphis Horns, Ann Peeples, Al Green, Otis Clay, Syl Johnson, and the Ike and Tina Turner Review. (Courtesy of www.americanclassicimages.com.)

The Summer Twin Drive-In was enlarged to four screens in 1985. The hourglass lights date back to the theatre's opening. After the loss of one screen tower, it remains a trio in 2013 and the only drive-in still operating in a county where there were once eight. Patrons have a choice of vintage speakers or radio reception. (Courtesy of Malco Theatres, Inc.)

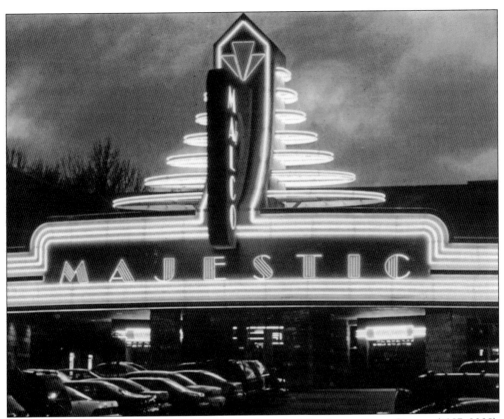

Malco's Majestic Cinema was built in 1997 across from the Winchester Court Cinema (1987–2008). The Winchester Court, Memphis's first eight-screen cinema, had a low-key front to match its shopping center. The Majestic, set back from Winchester Road, is freestanding and has an elaborate neon display. It has been compared to a classic hood ornament in blue neon. (Courtesy of Malco Theatres, Inc.)

Malco's Majestic has been called the city's first megaplex, with a total of 20 screens. Its lobby was the first to hearken back to the grand entries of the movie palace era and combines contemporary neon with classical lines and drapery. The entrances to the cinema auditoriums are on either side of the central concession stand. (Courtesy of Malco Theatres, Inc.)

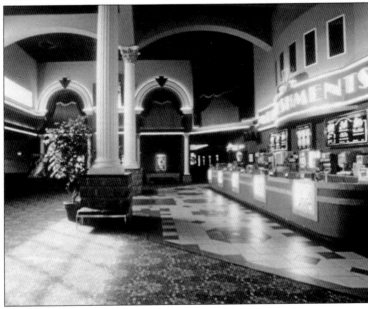

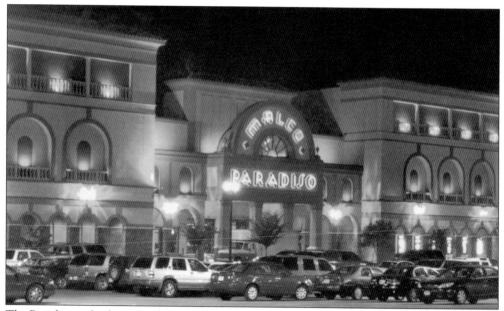

The Paradiso is the first of Malco's contemporary Memphis cinemas to have an ornate building. It is the premier first-run cinema in the area, with large-screen auditoriums and many special event showings such as performances of the Metropolitan Opera broadcast live during the season. All of Malco's cinemas have converted to digital projection. (Courtesy of Malco Theatres, Inc.)

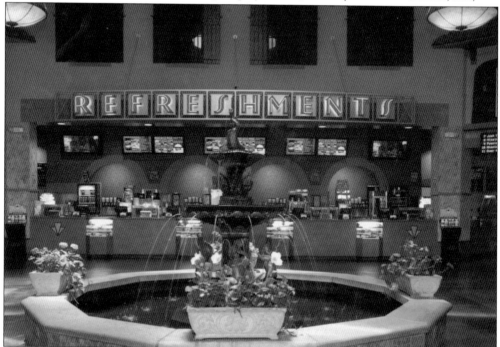

The Paradiso's huge lobby is beautifully decorated and patrons are surrounded with coming attraction displays both standing and on screen. The concession serves from a large menu. It has 14 screens and is situated in a busy commercial area bordered by Poplar Avenue and Mendenhall Road. (Courtesy of Malco Theatres, Inc.)

The center fountain, skylight, and surrounding balconies give the impression of a Spanish courtyard, once again remembering the grand foyers of past years. The cinema contains an arcade, coffee bar, party room, and a second concession for the auditoriums far from the lobby. It is the primary 3-D cinema in the area. (Courtesy of Malco Theatres, Inc.)

Studio on the Square heralded a long-awaited return of first-run movies to Midtown. In 2013, it has a bistro atmosphere with a lounge area on both ends of the concession and a covered patio. This room, to the left of the entrance, is a tribute to classic and camp movies of all eras and includes a vintage projector and lamp house. (Courtesy of Malco Theatres, Inc.)

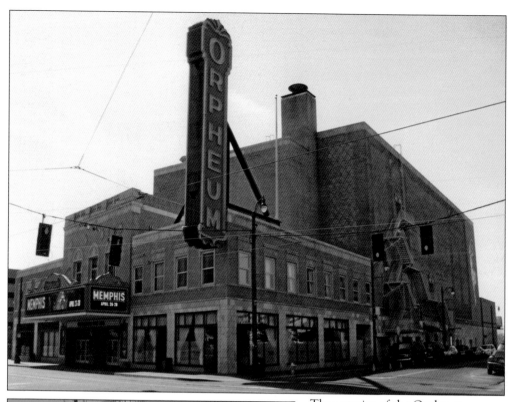

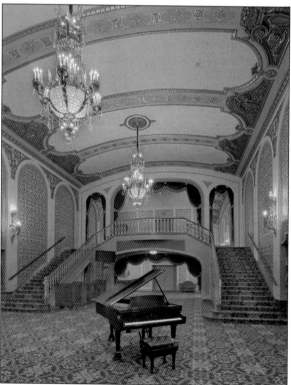

The exterior of the Orpheum Theatre has changed very little and will celebrate its 85th anniversary in 2013. A replica of the vertical sign replaced the aging original and the vintage marquee has a contemporary signboard. Otherwise, the view is the same as in 1928. The marquee advertises the Tony Award–winning musical *Memphis*, which was partially produced by and had its regional premiere at the Orpheum Theatre. (Courtesy of Patrick Whitney.)

The ornate Rapp & Rapp lobby is now connected to both the main floor storefronts; one is the Broadway Room for private parties and the other is the Parlor, with the main bar and main floor restrooms. The chandeliers and plasterwork are original, and the peach-tinted mirrors date from the mid-1940s. A smaller bar serves the lobby itself. (Courtesy of the Orpheum Theatre.)

The grandeur of the auditorium has been carefully restored, while improvements in lighting and sound have been added and upgraded. The first renovation was in 1982–1983, and a second renovation in 1996 expanded the stage for larger touring productions such as *Phantom of the Opera* and *Miss Saigon*. (Courtesy of the Orpheum Theatre.)

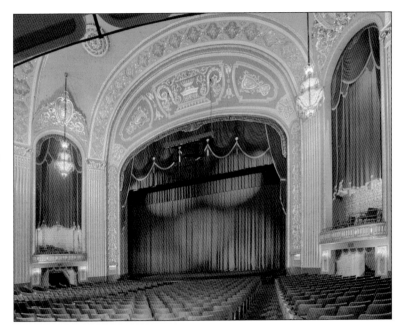

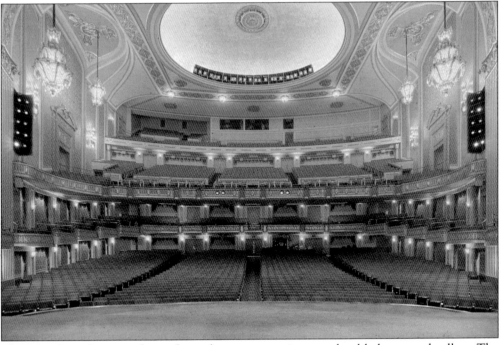

The view from the stage shows the orchestra, mezzanine, two-level balcony, and gallery. The booth is still equipped for films and stage shows, and the alterations for stage lighting can be seen. The 320-foot dome has a capacity for three colors. Smaller speakers augment the sound system, and individual amplification devices are available. The Malco also had a special section on the mezzanine where amplification was available. (Courtesy of the Orpheum Theatre.)

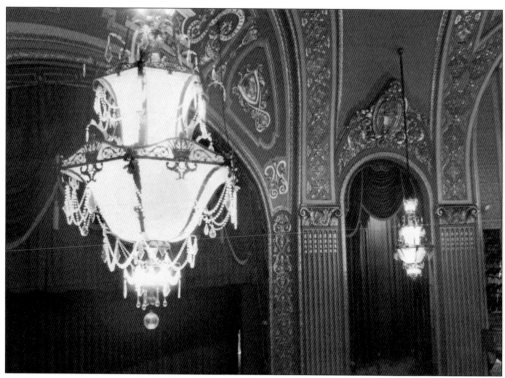

The south spotlight bay, created in the 1983 renovation, has this view of the two large chandeliers from balcony level, seen across the house. They are made of Czechoslovakian crystal and each bead has been hand-cut. Each fixture is approximately 12 feet high and was said to weigh 2,000 pounds in 1928. They must be raised and lowered by hand. (Photograph by David George, courtesy of the author.)

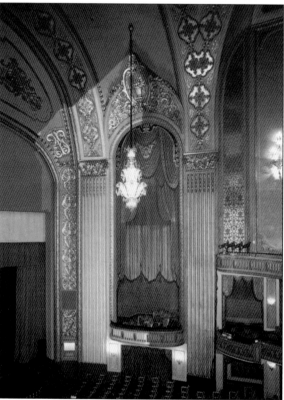

In this tall box, in Row C, Seat 5, people have reported seeing a white, glowing figure of a little girl. This apparition is known as Mary, and legend connects her with the first Orpheum Theatre, which she had visited many times, but also states that she died outside the theatre. This photograph shows a sample restoration of the plasterwork by Conrad Schmitt Studios prior to the 1983 renovation. (Courtesy of the Orpheum Theatre.)

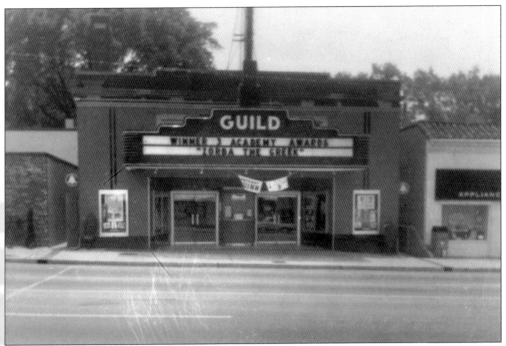

The Guild Art Theatre in the old Ritz Theatre building was for many years under the management of Bill Kendall. He presented controversial foreign and art films (and battled with the censors), and in 1969 the first public drag pageant in Memphis was held on Halloween at the Guild—despite a city ordinance against cross-dressing. The Miss Gay Memphis Pageant is considered the beginning of the gay/lesbian equality movement in Memphis. (Courtesy of MPLIC.)

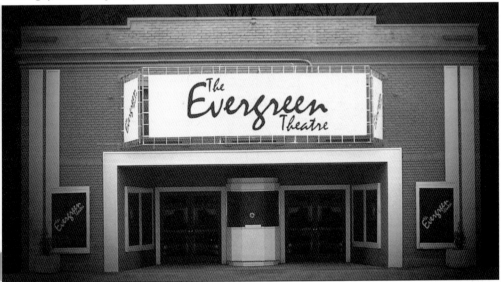

The building has become the Evergreen Theatre. Circuit Playhouse, Inc. bought the property in 1981 and renovated it in three months. The lobby still has its simple cove lighting and the gilded wreaths still light the reduced auditorium. The Evergreen now hosts Theatre For Youth, along with the Varnell building next door; the buildings house several small companies and have facilities that are available for rentals. (Courtesy of Playhouse on the Square, 2013.)

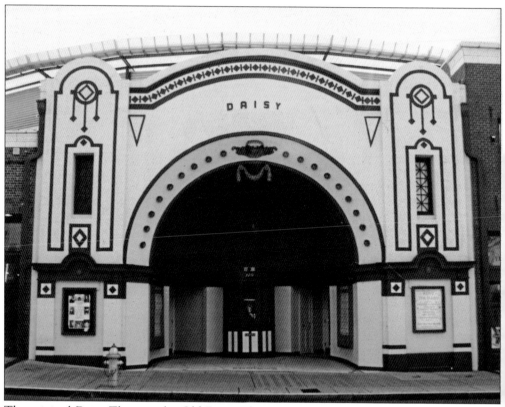

The original Daisy Theatre, the Old Daisy Theatre, was restored along with the remaining buildings on Beale Street in 1982. It has been used for vaudeville, as a museum, and as a dance club. All the intricate details of its stucco facade have been restored and it is a major Beale Street landmark. (Courtesy of Patrick Whitney, 2013.)

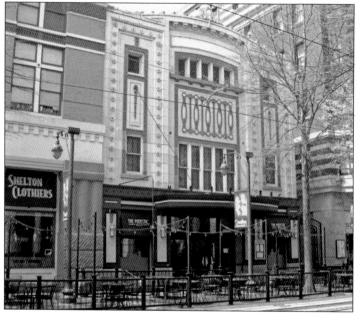

The Majestic Theatre was restored as a restaurant and microbrewery in the 1990s and has been operated by Deni and Patrick Reilly as the Majestic Grille since 2005, showing silent movies during open hours. The interior plasterwork had been hidden by a suspended ceiling and is now visible once again. Even some of the brackets for the oscillating fans from 1914 may be seen upstairs. (Courtesy of Patrick Whitney, 2013.)

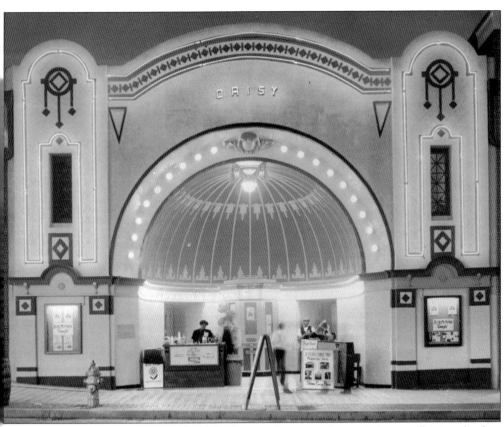

The Old Daisy Theatre was restored with both incandescent and neon lighting reflecting the days when it was most brilliant. Even when the theatre is not open, drinks are sold in the historic entry on weekends. It is used in 2013 as a special-event facility, with its interior beautifully restored and hung with photographs of famous Beale Street performers. (Courtesy of API Photographers.)

The New Daisy Theatre kept many of its 1941 appointments, but was completely remodeled inside into tiers of boxes with tables. A permanent stage set is a view of old Beale Street. It presents a full calendar of live entertainment and is also available for rentals. The marquee remains in full working order, minus the "New Daisy" letters. A blues band can be seen playing on the street. (Courtesy of Patrick Whitney, 2013.)

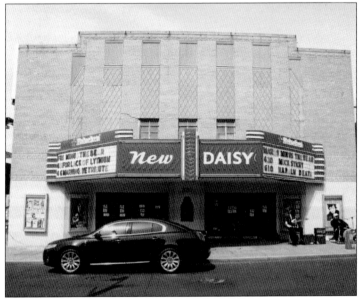

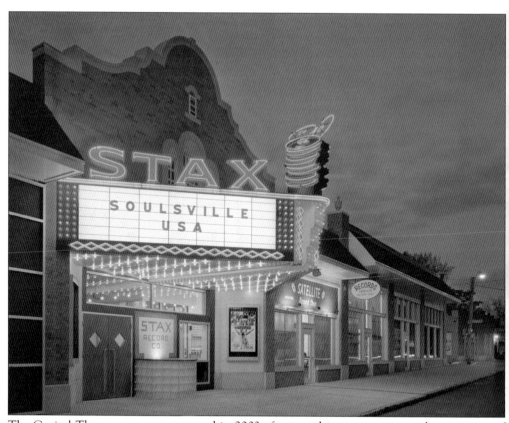

The Capitol Theatre was reconstructed in 2003 after a multiyear campaign to become part of Soulsville USA, which includes the Stax Museum of American Soul Music, Stax Music Academy, the Soulsville Foundation, and the Soulsville Charter School. A historic country church building illustrating the early roots of soul music and a recreation of the studio where so many Stax artists recorded are part of the museum. (Photograph by Esto, courtesy of Soulsville USA, 2013.)

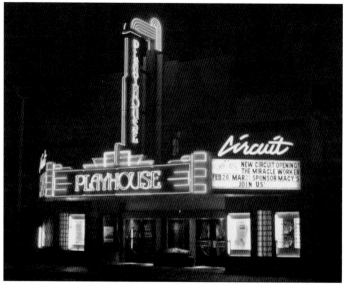

The Memphian Theatre was remodeled by Circuit Playhouse, Inc. in 1985. It housed Playhouse on the Square, the professional theatre company, until a new building was built across the street in 2010. Circuit Playhouse (the community theatre) then moved into the Memphian. The Memphian's legacy and outdoor display were carefully preserved and the neon "Memphian" letters decorate the Memphian Room beside the theatre. (Courtesy of Playhouse on the Square, 2013.)

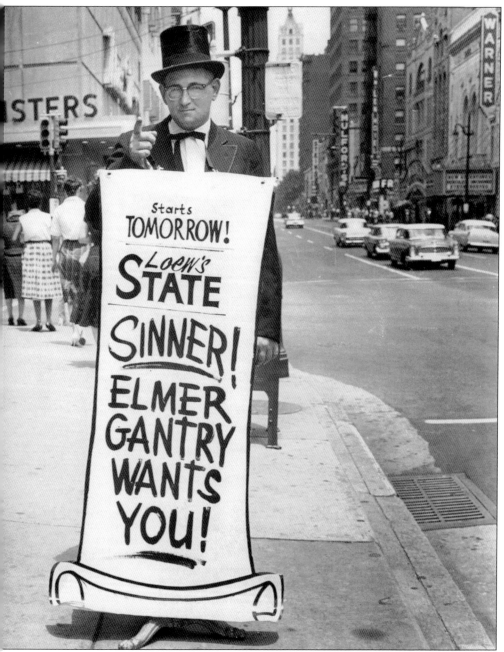

Many of the photographs in this book, like this 1958 *Elmer Gantry* promotion, first came to light in a Memphis Memoirs documentary produced by WKNO public television in 2002. Thanks go to WKNO and to Bonnie Daws Kourvelas and Jo Potter for producing such a fine piece of work. It was of inestimable use and inspiration during the writing of this book. (Courtesy of MPLIC.)

The End—a Vincent Astor production, MMXIII

Discover Thousands of Local History Books
Featuring Millions of Vintage Images

Arcadia Publishing, the leading local history publisher in the United States, is committed to making history accessible and meaningful through publishing books that celebrate and preserve the heritage of America's people and places.

Find more books like this at
www.arcadiapublishing.com

Search for your hometown history, your old stomping grounds, and even your favorite sports team.